DAVID BUSCH'S COMPACT FI....

NIKON® D3000

David D. Busch

Good Luck with your Nikon D3000!

Course Technology PTR

A part of Cengage Learning

COURSE TECHNOLOGY
CENGAGE Learning™

Australia, Brazil, Japan, Korea, Mexico, Singapore, Spain, United Kingdom, United States

COURSE TECHNOLOGY
CENGAGE Learning™

David Busch's Compact Field Guide for the Nikon® D3000

David D. Busch

Publisher and General Manager, Course Technology PTR:
Stacy L. Hiquet

Associate Director of Marketing:
Sarah Panella

Manager of Editorial Services:
Heather Talbot

Marketing Manager:
Jordan Castellani

Executive Editor:
Kevin Harreld

Project Editor:
Jenny Davidson

Technical Reviewer:
Michael D. Sullivan

Interior Layout Tech:
Bill Hartman

Cover Designer:
Mike Tanamachi

Indexer:
Katherine Stimson

Proofreader:
Sara Gullion

Course Technology, a part of Cengage Learning
20 Channel Center Street
Boston, MA 02210
USA

For product information and technology assistance, contact us at **Cengage Learning Customer & Sales Support, 1-800-354-9706.**

For permission to use material from this text or product, submit all requests online at **cengage.com/permissions**. Further permissions questions can be e-mailed to **permissionrequest@cengage.com**.

Nikon is a registered trademark of Nikon Corporation in the United States and other countries.

All other trademarks are the property of their respective owners.

All images © David D. Busch unless otherwise noted.

Library of Congress Control Number: 2010933080

ISBN-13: 978-1-4354-5872-7

ISBN-10: 1-4354-5872-9

Cengage Learning is a leading provider of customized learning solutions with office locations around the globe, including Singapore, the United Kingdom, Australia, Mexico, Brazil, and Japan. Locate your local office at:
international.cengage.com/region

Cengage Learning products are represented in Canada by Nelson Education, Ltd.

For your lifelong learning solutions, visit **courseptr.com**.

Visit our corporate Web site at **cengage.com**.

Printed in the United States of America
1 2 3 4 5 6 7 12 11 10

Contents

Introduction

Throw away your cheat-sheets and command cards! Are you tired of squinting at tiny color-coded tables on fold-out camera cards? Do you wish you had the most essential information extracted from my comprehensive *David Busch's Nikon D3000 Guide to Digital SLR Photography* in a size you could tuck away in your camera bag? I've condensed the basic reference material you need in this handy, lay-flat book, *David Busch's Compact Field Guide for the Nikon D3000*. In it, you'll find the explanations of *why* to use each setting and option—information that is missing from the cheat-sheets and the book packaged with the camera. You *won't* find the generic information that pads out the other compact guides. I think you'll want to have both this reference and my full-sized guide—one to help you set up and use your Nikon D3000, and the other to savor as you master the full range of things this great camera can do.

About the Author

With more than a million books in print, **David D. Busch** is the world's #1 selling digital camera guide author, and the originator of popular digital photography series like *David Busch's Pro Secrets, David Busch's Quick Snap Guides,* and *David Busch's Guides to Digital SLR Photography.* As a roving photojournalist for more than 20 years, he illustrated his books, magazine articles, and newspaper reports with award-winning images. Busch operated his own commercial studio, suffocated in formal dress while shooting weddings-for-hire, and shot sports for a daily newspaper and upstate New York college. His photos and articles have appeared in *Popular Photography & Imaging, The Rangefinder, The Professional Photographer,* and hundreds of other publications. He's also reviewed dozens of digital cameras for CNet and *Computer Shopper,* and his advice has been featured on NPR's *All Tech Considered.* Visit his website at www.dslrguides.com/blog.

Chapter 1

Quick Setup Guide

This chapter contains the essential information you need to get your Nikon D3000 prepped and ready to go. You'll learn how to use a few of the basic controls and features, and how to transfer your photos to your computer. If you want a more complete map of the functions of your camera, skip ahead to Chapter 2.

Pre-Flight Checklist

The initial setup of your Nikon D3000 is fast and easy. You just need learn a few controls, charge the battery, attach a lens, and insert a Secure Digital card.

Charging the Battery

When the battery is inserted into the MH-18a charger properly (it's impossible to insert it incorrectly), an orange Charge light begins flashing, and remains flashing until the status lamp glows steadily indicating that charging is finished, generally within two to three hours. When the battery is charged, slide the latch on the bottom of the camera and ease the battery in, as shown in Figure 1.1.

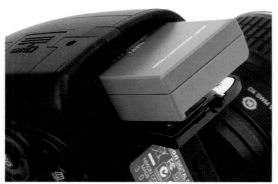

Figure 1.1
Insert the battery in the camera; it only fits one way.

Introducing Menus and the Multi Selector

You'll find descriptions of most of the controls used with the Nikon D3000 in Chapter 2, which provides a complete "roadmap" of the camera's buttons and dials and switches. However, you may need to perform a few tasks during this initial setup process, and most of them will require the MENU button and the multi selector pad.

- **MENU button.** It's located to the left of the LCD, the second button from the top. When you want to access a menu, press it. To exit most menus, press it again.

- **Multi selector pad.** A thumbpad-sized button with indentations at the North, South, East, and West "navigational" positions, plus a button in the center marked "OK" (see Figure 1.2). With the D3000, the multi selector is used exclusively for navigation; for example, to navigate among menus on the LCD or to choose one of the eleven focus points, to advance or reverse display of a series of images during picture review, or to change the kind of photo information displayed on the screen. The OK button is used to confirm your choices and send the image currently being viewed to the Retouch menu for modification.

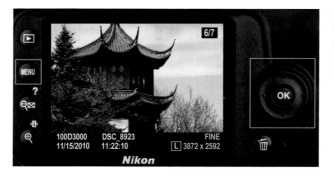

Figure 1.2
The MENU button (left) and multi selector pad (right).

Setting the Clock

The in-camera clock might have been set for you by someone checking out your camera prior to delivery, but if you do need to set it, the flashing **CLOCK** indicator roughly in the center of the monochrome top-panel LCD will be the giveaway. Press the MENU button to the left of the LCD, and then use the multi selector to scroll down to the Setup menu (it's marked with a wrench icon), press the multi selector button to the right, and then press the down button to scroll down to **Time zone and date**, and press the right button again. The options will appear on the screen that appears next.

Mounting the Lens

If your D3000 has no lens attached, you'll need to mount one before shooting:

1. Select the lens and loosen (but do not remove) the rear lens cap.

2. Remove the body cap on the camera by rotating the cap towards the lens release button.

3. Once the body cap has been removed, remove the rear lens cap from the lens, set it aside, and then mount the lens on the camera by matching the alignment indicator on the lens barrel with the white dot on the camera's lens mount (see Figure 1.3). Rotate the lens toward the shutter release until it seats securely.

4. Set the focus mode switch on the lens to AF or M/A (Autofocus). If the lens hood is bayoneted on the lens in the reversed position, twist it off and remount with the "petals" (if present) facing outward. A lens hood protects the front of the lens from accidental bumps, and reduces flare caused by extraneous light arriving at the front of the lens from outside the picture area.

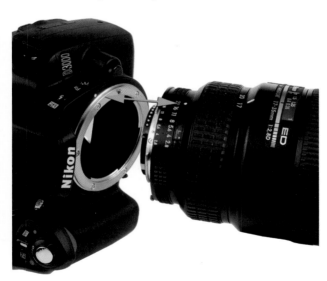

Figure 1.3
Match the indicator on the lens with the white dot on the camera mount to properly align the lens with the bayonet mount.

Adjusting Diopter Correction

If you are a glasses wearer and want to use the D3000 without your glasses, or to add further correction, you can take advantage of the camera's built-in diopter adjustment, which can be varied from −2 to +1.0 correction. Press the shutter release halfway to illuminate the indicators in the viewfinder, then move the

diopter adjustment slider next to the viewfinder (see Figure 1.4) while looking through the viewfinder until the indicators appear sharp. Should the available correction be insufficient, Nikon offers nine different Diopter-Adjustment Viewfinder Correction lenses for the viewfinder window, ranging from –1.7 to +0.5, at a cost of $15-$20 each.

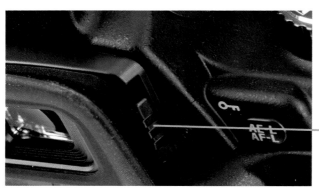

Figure 1.4
Viewfinder diopter correction from –1.7 to +0.5 can be dialed in.

Diopter correction slider

Inserting and Formatting a Secure Digital Card

Next, insert a Secure Digital memory card. Slide the cover on the right side of the camera towards the back, and then open it. You should only remove the memory card when the camera is switched off, or, at the very least, when the yellow-green card access light (just to the right of the Trash button on the back of the camera) that indicates the D3000 is writing to the card is not illuminated.

Insert the memory card with the label facing the back of the camera, oriented so the edge with the gold connectors goes into the slot first (see Figure 1.5). Close the door, and, if this is your first use of the card, format it (described next). When you want to remove the memory card later, press the card inwards, and it will pop right out.

I recommend formatting the memory card before each shooting session, to ensure that the card has a fresh file system, and doesn't have stray files left over. Format *only* when you've transferred all the images to your computer, of course.

■ **Setup menu format.** Press the MENU button, use the up/down buttons of the multi selector to choose the Setup menu (which is represented by that wrench icon), navigate to the **Format memory card** entry with the right button of the multi selector, and select **Yes** from the screen that appears. Press OK (in the center of the multi selector pad) to begin the format process.

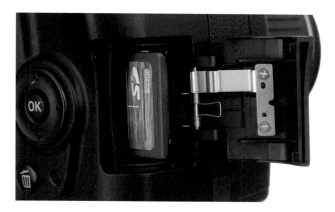

Figure 1.5
The Secure Digital card is inserted with the label facing the back of the camera.

Selecting an Exposure Mode

The Nikon D3000 has two types of exposure modes: Scene modes, in which the camera makes virtually all the shooting decisions for you, and Advanced modes, which include semi-automatic and manual exposure modes.

Choosing a Scene Mode

The eight Scene modes can be selected by rotating the mode dial on the top right of the Nikon D3000 to the appropriate icon (shown in Figure 1.6):

- **Auto.** The D3000 makes all the exposure decisions for you, and will pop up the internal flash if necessary under low-light conditions. The camera automatically focuses on the subject closest to the camera (unless you've set the lens to Manual focus), and the autofocus assist illuminator lamp on the front of the camera will light up to help the camera focus in low-light conditions.

- **Auto (Flash Off).** Identical to Auto mode, except that the flash will not pop up under any circumstances. You'd want to use this in a museum, during religious ceremonies, concerts, or any environment where flash is forbidden or distracting.

- **Portrait.** Use this mode when taking a portrait of a subject standing relatively close to the camera and want to de-emphasize the background, maximize sharpness, and produce flattering skin tones. The built-in flash will pop up if needed.

- **Landscape.** Select this mode when you want extra sharpness and rich colors of distant scenes. The built-in flash and AF-assist illuminator are disabled.

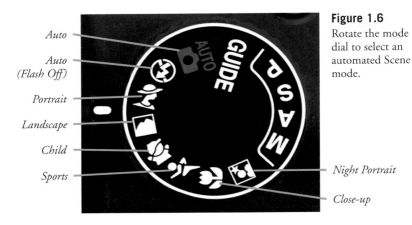

Auto

Auto (Flash Off)

Portrait

Landscape

Child

Sports

Night Portrait

Close-up

Figure 1.6

Rotate the mode dial to select an automated Scene mode.

- **Child.** Use this mode to accentuate the vivid colors often found in children's clothing, and to render skin tones with a soft, natural-looking texture. The D3000 focuses on the closest subject to the camera. The built-in flash will pop up if needed.

- **Sports.** Use this mode to freeze fast-moving subjects. The D3000 selects a fast shutter speed to stop action, and focuses continuously on the center focus point while you have the shutter release button pressed halfway. However, you can select one of the other two focus points to the left or right of the center by pressing the multi selector left/right buttons. The built-in electronic flash and focus assist illuminator lamp are disabled.

- **Close-up.** This mode is helpful when you are shooting close-up pictures of a subject from about one foot away or less, such as flowers, bugs, and small items. The D3000 focuses on the closest subject in the center of the frame, but you can use the multi selector right and left buttons to focus on a different point. Use a tripod in this mode, as exposures may be long enough to cause blurring from camera movement. A lens with VR (vibration reduction) features can also help reduce blurring. The built-in flash will pop up if needed.

- **Night Portrait.** Choose this mode when you want to illuminate a subject in the foreground with flash (it will pop up automatically, if needed), but still allow the background to be exposed properly by the available light. The camera focuses on the closest main subject. Be prepared to use a tripod or a vibration-resistant lens like the 18-55 VR kit lens to reduce the effects of camera shake.

Choosing an Advanced Mode

The advanced modes include Programmed auto (or Program mode), Shutter-priority, Aperture-priority, and Manual exposure mode, known collectively as PSAM modes, for their initials. These are the modes that allow you to specify how the camera chooses its settings when making an exposure for greater creative control. Figure 1.7 shows the position of the modes described next.

- **P (Program).** This mode allows the D3000 to select the basic exposure settings, but you can still override the camera's choices to fine-tune your image, while maintaining metered exposure.

- **S (Shutter-priority).** This mode is useful when you want to use a particular shutter speed to stop action or produce creative blur effects. Choose your preferred shutter speed, and the D3000 will select the appropriate f/stop for you.

- **A (Aperture-priority).** Choose when you want to use a particular lens opening, especially to control sharpness or how much of your image is in focus. Specify the f/stop you want, and the D3000 will select the appropriate shutter speed for you.

- **M (Manual).** Select when you want full control over the shutter speed and lens opening, either for creative effects or because you are using a studio flash or other flash unit not compatible with the D3000's automatic flash metering.

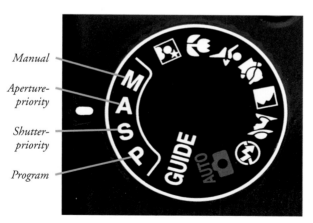

Manual

Aperture-priority

Shutter-priority

Program

Figure 1.7
Rotate the mode dial to select an advanced mode.

Choosing a Release Mode

The release mode determines when (and how often) the D3000 makes an exposure. Your D3000 has five release modes: Single frame, Continuous (Burst), Self-timer, Delayed remote, and Quick-response remote. (The latter two require the use of the optional ML-L3 infrared remote control.)

There are several ways to specify one of the five release modes. You can use the Shooting menu Settings entry's **Release mode** option (as described in Chapter 3) to choose one of the five modes as the default; thereafter, that mode will be invoked when you press the Fn button located near the D3000's nameplate on the front of the camera. Or, you can use the information edit display, which allows you to change many of the D3000's basic settings.

Using the Information Edit Display

When you press the information edit button on the back of the camera (the bottom button on the left side of the LCD; not to be confused with the Info button on the top of the camera), the shooting information display (shown at left in Figure 1.8) appears. You can also show or hide this screen by pressing the Info button on top of the camera. (The difference between the two is simple: the Info button just turns the shooting information screen on or off; the information edit button does the same thing, but a second press kicks the camera into information edit mode, which allows you to change many of the settings.)

The shooting information display is a useful status screen. (Shown in the figure is the "Classic" version. A "Graphic" version is also available; in Chapter 3, I'll show you how to select it using the Information Edit Display Format entry in

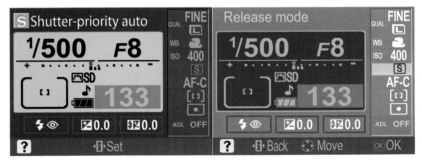

Figure 1.8 The shooting information display (left) shows the status of your current settings. Press the information edit button a second time to use the information edit screen (right) to modify your options.

the Setup menu.) Press the information edit button again to access the information edit screen (shown at right in Figure 1.8), which allows you to modify the most frequently accessed options.

To change release modes, follow these steps:

1. If the LCD screen is blank, press the Zoom In/information edit button twice to access the information edit screen.

2. Use the multi selector pad's left/right/up/down buttons to navigate to the settings at the side of the screen, and up to the **Release mode** option. (It's the fifth entry down from the top.)

3. Press the OK button in the center of the multi selector pad to produce the **Release mode** screen, which has four options.

4. To activate the self-timer, for example, select the icon resembling a clock face with the timer delay period next to it. This is **10s** by default, but can be changed to 2, 5, or 20 seconds in the Setup menu entry **Self-timer delay** (as described in Chapter 3). Alternatively, you can select one of the other release modes.

5. Press the OK button to confirm your choice.

6. Press the information edit button to exit the screen.

The release modes available from the information edit menu are as follows:

■ **Single frame.** In this single-shot mode, the default, the D3000 takes one picture each time you press the shutter release button down all the way. If you press the shutter and nothing happens (which is very frustrating!), you may be using a focus mode that requires sharp focus to be achieved before a picture can be taken. This is called focus priority, and it is discussed in more detail under "Choosing Focus Modes," later in this chapter.

■ **Continuous.** This shooting mode can be set to produce bursts of three frames per second, useful for grabbing action shots of sports, or for capturing fleeting expressions (especially of children).

■ **Self-timer.** You can use the self-timer as a replacement for a remote release, to reduce the effects of camera/user shake when the D3000 is mounted on a tripod or, say, set on a firm surface, or when you want to get in the picture yourself. The picture will be taken after about 10 seconds (or 2, 5, or 20 seconds if you've changed the default value). A white lamp on the front of the camera will blink while the timer counts down, then remain on continuously for about two seconds just before the picture is taken. Any time you use the camera on a tripod (with the self-timer or otherwise) make sure there is no bright light shining on the viewfinder window; if so, cover it or

locate that eyepiece cap and block the window. Self-timer mode is not "sticky." After you take one picture with the self-timer, the D3000 returns to Single frame mode.

- **Delayed remote.** Set this release mode and the D3000 will take a picture two seconds after you press the button on the ML-L3 infrared remote control. This mode is "sticky." It remains in force until you turn it off manually, or simply turn off the D3000 and turn it back on.

- **Quick-response remote.** With this choice activated, the D3000 takes the photo as soon as you press the button on the ML-L3 infrared remote control. This mode is also "sticky." It remains in force until you turn it off manually, or simply turn off the D3000 and turn it back on.

Choosing a Metering Mode

The metering mode you select determines how the D3000 calculates exposure. To change metering modes, use the information edit screen. (You can also specify metering mode using the Shooting menu, as I'll describe in Chapter 3.)

1. Press the information edit button twice and navigate to the metering selection (it's near the bottom of the right-hand column) using the multi selector buttons.
2. Press OK to select the option.
3. Use the multi selector up/down buttons to choose **Matrix**, **Center-weighted**, or **Spot** metering (described below and represented by the icons shown in Figure 1.9).

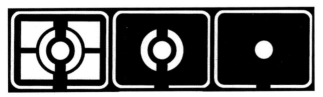

Figure 1.9
Metering mode icons are (left to right): Matrix, Center-weighted, Spot.

4. Press OK to confirm your choice.
5. Press the information edit button to exit, or just tap the shutter release button.

- **Matrix metering.** The standard metering mode; the D3000 attempts to intelligently classify your image and choose the best exposure based on readings from a 420-segment color CCD sensor that interprets light reaching the viewfinder using a database of hundreds of thousands of patterns.

- **Center-weighted metering.** The D3000 meters the entire scene, but gives the most emphasis to the central area of the frame, measuring about 8mm.

- **Spot metering.** Exposure is calculated from a smaller 3.5 mm central spot, about 2.5 percent of the image area.

Choosing a Focus Mode

When you are using Program, Shutter-priority, Aperture-priority, or Manual exposure mode, you can select the autofocus mode *when* the D3000 measures and locks in focus prior to pressing the shutter release down all the way and taking the picture. The focus mode is chosen using the information edit screen.

1. Press the information edit button twice and navigate to the **Focus mode** selection (it's sixth from the top of the right-hand column) using the multi selector buttons.

2. Press OK to select the option.

3. Use the multi selector up/down buttons to choose **AF-A**, **AF-C**, **AF-S**, or **M** (described next).

4. Press OK to confirm your choice.

5. Press the information edit button to exit, or just tap the shutter release button.

The four focus modes are as follows:

- **Automatic autofocus (AF-A).** This default setting switches between AF-C and AF-S, as described below.

- **Continuous-servo autofocus (AF-C).** This mode, sometimes called *Continuous Autofocus*, sets focus when you partially depress the shutter button (or other autofocus activation button), but continues to monitor the frame and refocuses if the camera or subject is moved. This is a useful mode for photographing sports and moving subjects.

- **Single-servo autofocus (AF-S).** This mode, sometimes called *Single Autofocus*, locks in a focus point when the shutter button is pressed down halfway, and the focus confirmation light glows at bottom left in the viewfinder. The focus will remain locked until you release the button or take the picture. This mode is best when your subject is relatively motionless.

- **Manual focus (M).** When focus is set to Manual, you always focus manually using the focus ring on the lens. The focus confirmation indicator in the viewfinder provides an indicator when correct focus is achieved. Note that the Autofocus/Manual focus switch on the lens and the setting made in camera body must agree; if either is set to Manual focus, then the D3000 defaults to Manual focus regardless of how the other is set.

Choosing an AF-Area Mode

Autofocus-area mode determines the zones in your scene used to achieve focus, from among the eleven points available in the viewfinder. (See Figure 1.10.)

1. Press the information edit button twice and navigate to the **AF-area** mode selection (it's seventh from the top of the right-hand column) using the multi selector buttons.
2. Press OK to select the option.
3. Use the multi selector up/down buttons to choose **Single point**, **Dynamic area**, **Auto-area**, or **3D-tracking (11 points)** (described below).
4. Press OK to confirm your choice.
5. Press the information edit button to exit, or just tap the shutter release button.

Figure 1.10
Eleven different focus points can be selected automatically or manually.

- **Single point.** You always choose which of the eleven points are used, and the Nikon D3000 sticks with that focus bracket, no matter what. This mode is best for non-moving subjects.
- **Dynamic area.** You can choose which of the eleven focus zones to use, but the D3000 will switch to another focus mode when using AF-C or AF-A mode and the subject moves. This mode is great for sports or active children.
- **Auto-area.** This default mode chooses the focus point for you, and can use distance information when working with a lens that has a G or D suffix in its name.
- **3D-tracking (11 points).** You can select the focus zone, but when not using AF-S mode, the camera refocuses on the subject if you reframe the image.

Adjusting White Balance and ISO

If you like, you can custom-tailor your white balance (color balance) and ISO (sensitivity) settings. To start out, it's best to set white balance (WB) to Auto, and ISO to ISO 200 for daylight photos, and ISO 400 for pictures in dimmer light. You can adjust either one now using the information edit screen, as described multiple times in this chapter. I won't repeat the instructions again. The WB (for white balance) and ISO settings are third and fourth from the top of the right-hand column in the information edit screen (respectively).

Reviewing the Images You've Taken

The Nikon D3000 has a broad range of playback and image review options. (See Figure 1.11.)

- **Display an image.** Press the Playback button (marked with a white right-pointing triangle) at the upper-left corner of the back of the camera to display the most recent image on the LCD.

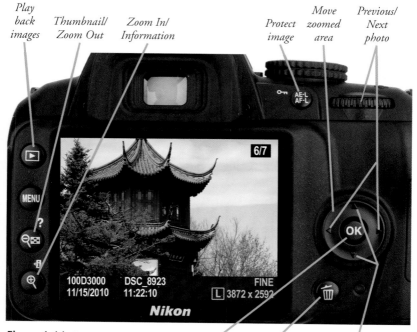

Figure 1.11 Review your images.

Play back images

Thumbnail/ Zoom Out

Zoom In/ Information

Protect image

Move zoomed area

Previous/ Next photo

Edit current image in Retouch menu

Delete photo

Change type of information displayed

- **Scroll among images.** Spin the command dial left or right to review additional images. You can also use the multi selector left/right buttons. Press right to advance to the next image, or left to go back to a previous image.
- **Change image information display.** Press the multi selector button up or down to change among overlays of basic image information or detailed shooting information.
- **Magnify/reduce image on screen.** Press the Zoom In button repeatedly to zoom in on the image displayed; the Zoom Out button reduces the image. A thumbnail representation of the whole image appears in the lower-right corner with a yellow rectangle showing the relative level of zoom. At intermediate zoom positions, the yellow rectangle can be moved around within the frame using the multi selector.
- **Protect images.** Press the Protect button to mark an image and shield it from accidental erasure (but not from reformatting of the memory card).
- **Delete current image.** Press the Trash button twice to remove the photo currently being displayed.
- **Exit playback.** Press the Playback button again, or just tap the shutter release button to exit playback view.

Using the Built-in Flash

The built-in flash is easy enough to work with that you can begin using it right away, either to provide the main lighting of a scene or as supplementary illumination to fill in the shadows.

- **Activating flash in Scene modes:** The built-in flash will pop up automatically as required in Auto, Portrait, Child, Close-up, and Night Portrait Scene modes.
- **Activating flash in advanced modes:** To use the built-in flash in Manual, Aperture-priority, Shutter-priority, or Program modes, just press the flash pop-up button (shown in Figure 1.12). When the flash is fully charged, a lightning bolt symbol will flash at the right side of the viewfinder display.
- **In P and A modes:** When using P (Program) and A (Aperture-priority) exposure modes, the D3000 will select a shutter speed for you automatically from the range 1/200th to 1/60th seconds. You can select an aperture, and the flash exposure will be calculated automatically.
- **In S (Shutter-priority) mode:** You select the shutter speed from 1/200th to 30 seconds, and the flash exposure will be calculated automatically.
- **In M (Manual) mode:** You select the shutter speed from 1/200th (the highest shutter speed that can be used in standard flash modes) to 30 seconds, and aperture. The flash exposure will be calculated automatically.

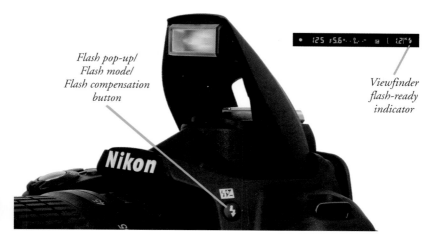

Flash pop-up/
Flash mode/
Flash compensation
button

Viewfinder
flash-ready
indicator

Figure 1.12 The pop-up electronic flash can be used as the main light source or for supplemental illumination.

The final step in your picture taking session will be to transfer the photos you've taken to your computer for printing, further review, or image editing. Your D3000 allows you to print directly to PictBridge-compatible printers and to create print orders right in the camera, plus you can select which images to transfer to your computer.

I recommend using a card reader attached to your computer to transfer files, because that process is generally a lot faster and doesn't drain the D3000's battery. However, you can also use a cable for direct transfer, which may be your only option when you have the cable and a computer, but no card reader (perhaps you're using the computer of a friend or colleague, or at an Internet café).

To transfer images from the camera to a Mac or PC computer using the USB cable:

1. Turn off the camera.
2. Pry back the rubber cover that protects the D3000's USB port, and plug the USB cable furnished with the camera into the USB port. (See Figure 1.13.)
3. Connect the other end of the USB cable to a USB port on your computer.
4. Turn the camera on. The operating system itself, or installed software such as Nikon Transfer or Adobe Photoshop Elements Transfer usually detects the camera and offers to copy or move the pictures. Or, the camera appears on your desktop as a mass storage device, enabling you to drag and drop the files to your computer.

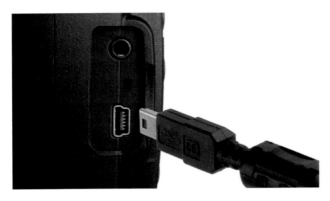

Figure 1.13
Images can be transferred to your computer using a USB cable.

To transfer images from a Secure Digital card to the computer using a card reader, do the following:

1. Turn off the camera.

2. Slide open the memory card door and remove the SD card.

3. Insert the Secure Digital card into your memory card reader. Your installed software detects the files on the card and offers to transfer them. The card can also appear as a mass storage device on your desktop, which you can open and then drag and drop the files to your computer.

Using the Guide Menu

The GUIDE position on the mode dial gives you fast access to some of the most-used commands, through an easy to navigate series of screens that leads you right through accessing the functions you need to shoot, view, or delete your photos, or set up the D3000 camera.

The Guide menu doesn't really need much in the way of instructions—once you rotate the mode dial to the GUIDE position, you can easily figure out what you want to do by following the menus and prompts. But that's the whole idea—the Guide menu is designed for absolute newbies to the Nikon D3000, who want to do simple tasks without the need to read even the abbreviated instructions provided in the printed manual.

Rotate the mode dial to GUIDE and the LCD lights up with the screen shown in Figure 1.14. You can choose guides for shooting, viewing/deleting images, and setting up your camera. Use the left/right buttons on the multi selector pad to highlight the options you want to explore, and then press the OK button in the center of the pad. If you choose **Shoot**, you'll see a simple menu like the one shown in Figure 1.15.

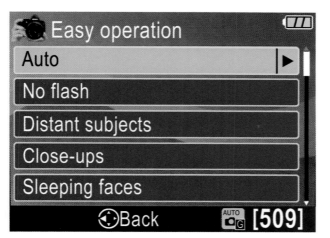

Figure 1.14
Rotate the mode dial to GUIDE to use the ultra-easy Guide menu.

Figure 1.15
Easy operation corresponds to the Scene modes located on the mode dial.

There are only three options. You can use the up/down buttons to highlight one, then press the multi selector right button to view that menu:

■ **Easy operation.** This lists functions like Auto, No Flash, Distant Subjects, Close-ups, Sleeping Faces, Moving Subjects, Landscapes, Portraits, and Night Portraits. (If you haven't jumped directly to this section from the beginning of the chapter, you might recognize that these options correspond roughly to the Scene modes that are also built into the mode dial, only with slightly "simplified" names. The **Easy operation** choices are shown in

Figure 1.16. Select one, and you'll see a screen of instructions and the choice of starting shooting or viewing additional settings you might want to change.

- **Advanced operation.** This choice has three options: **Soften Backgrounds**, **Freeze Motion (People)**, and **Freeze Motion (vehicles)**. Selecting any of them sets up the camera for that type of picture, and provides you with a screen of information explaining how to take the picture.

- **Timers & remote control.** This option allows you to select from Single frame, Continuous shooting, Self-timer, Delayed remote, and Quick-response remote.

Figure 1.16
Choose any of these available Easy operations and you'll be shown a screen with instructions on how to take the picture.

Chapter 2

Nikon D3000 Roadmap

You should find this Streetsmart Roadmap of the functions of the D3000's controls more useful than the tiny black-and-white drawings in the manual packed with the camera, which has dozens of cross-references that send you on an information scavenger hunt through dozens of pages. Everything you need to know about the controls themselves is here. You'll find descriptions of menus and settings in Chapters 3 and 4.

Nikon D3000: Front View

Figure 2.1 shows a front view of the Nikon D3000 from a 45-degree angle. The main components you need to know about are as follows:

- **Shutter button.** Angled on top of the hand grip is the shutter release button, which has multiple functions. Press this button down halfway to lock exposure and focus. Press it down all the way to actually take a photo or sequence of photos if you're using the Continuous shooting mode. Tapping the shutter button when the D3000's exposure meters have turned themselves off reactivates them, and a tap can be used to remove the display of a menu or image from the rear color LCD.
- **On/Off switch.** Turns the D3000 on or off.
- **Red-eye reduction/self-timer/autofocus assist lamp.** This LED provides a blip of light shortly before a flash exposure to cause the subjects' pupils to close down, reducing the effect of red-eye reflections off their retinas. When using the self-timer, this lamp also flashes to mark the countdown until the photo is taken, and serves to provide some extra illumination in dark environments to assist the autofocus system.
- **Hand grip.** This provides a comfortable hand-hold, and also contains the D3000's battery.

Figure 2.1

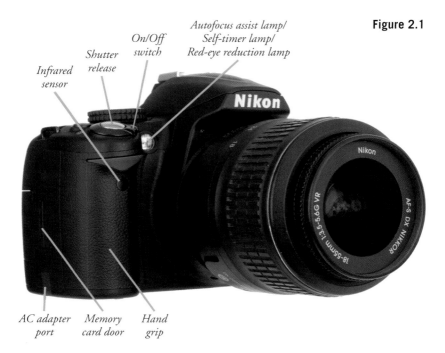

Infrared sensor

Shutter release

On/Off switch

Autofocus assist lamp/ Self-timer lamp/ Red-eye reduction lamp

AC adapter port

Memory card door

Hand grip

- **Memory card door.** Slide this door toward the back of the camera to provide access to the SD memory card slot.
- **Infrared sensor.** You can trigger the D3000 remotely using the optional ML-L3 infrared remote control, which is detected by this sensor.
- **AC adapter port.** Connect the optional EP-5 power cable from the EH-5a AC adapter into this port.

Figure 2.2 shows a front view of the Nikon D3000 from the other side, with the electronic flash elevated. The controls here include:

- **Self-timer/Fn (Function button).** This conveniently located button can be programmed to perform any one of several functions (including changing the image quality, setting ISO, or specifying white balance), but its default behavior is to activate the self-timer (which is then triggered when you press the shutter release button). I recommend retaining the default self-timer behavior.
- **Lens release button.** Press this button to unlock the lens, and then rotate it away from the shutter release button to dismount your optics.

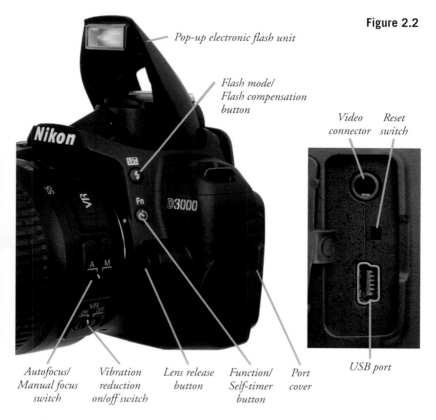

Figure 2.2

Pop-up electronic flash unit

Flash mode/
Flash compensation
button

Video Reset
connector switch

Nikon

D3000

Autofocus/ Vibration Lens release Function/ Port USB port
Manual focus reduction button Self-timer cover
switch on/off switch button

- **Flash pop-up/Flash mode button.** This button releases the built-in flash
 so it can flip up and start the charging process. If you decide you do not
 want to use the flash, you can turn it off by pressing the flash head back
 down. Hold down this button while spinning the command dial to choose
 a flash mode. I'll explain how to use the various flash modes (red-eye reduc-
 tion, front/rear curtain sync, and slow sync) in Chapter 5, along with some
 tips for adjusting flash exposure.

- **Pop-up flash.** The flash elevates from the top of the camera, theoretically
 reducing the chances of red-eye reflections, because the higher light source
 is less likely to reflect back from your subjects' eyes into the camera lens.
 In practice, the red-eye effect is still possible (and likely), and can be fur-
 ther minimized with the D3000's red-eye reduction lamp (which flashes
 before the exposure, causing the subjects' pupils to contract), and the after-
 shot red-eye elimination offered in the Retouch menu. (Your image editor
 may also have anti-red-eye tools.) Of course, the best strategy is to use an

external Speedlight that mounts on the accessory shoe on top of the camera (and thus is even higher) or a flash that is off-camera entirely.

- **Video port.** You can link this connector with a television to view your photos on a large screen.
- **Reset switch.** Press to reset basic camera settings.
- **USB port.** Plug in the USB cable furnished with your Nikon D3000 and connect the other end to a USB port in your computer to transfer photos.

The Nikon D3000's Back Panel

The back panel of the Nikon D3000 bristles with almost a dozen different controls, buttons, and knobs. That might seem like a lot of controls to learn, but you'll find that it's a lot easier to press a dedicated button and spin a dial than to jump to a menu every time you want to access one of these features. You can see the controls clustered along the top edge of the back panel in Figure 2.3. The key buttons and components and their functions are as follows:

- **Viewfinder eyepiece.** You can frame your composition by peering into the viewfinder. It's surrounded by a soft rubber eyecup that seals out extraneous light when pressing your eye tightly up to the viewfinder, and it also protects your eyeglass lenses (if worn) from scratching. It can be removed and replaced by the DK-5 eyepiece cap when you use the camera on a tripod, to ensure that light coming from the back of the camera doesn't venture inside and possibly affect the exposure reading. Shielding the viewfinder with your hand may be more convenient (unless you're using the self-timer to get in the photo yourself).
- **Diopter adjustment slider.** Move this slider up or down to adjust the diopter correction for your eyesight, as described in Chapter 1.

Figure 2.3

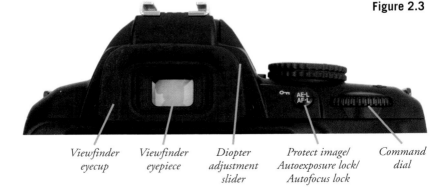

Viewfinder eyecup *Viewfinder eyepiece* *Diopter adjustment slider* *Protect image/ Autoexposure lock/ Autofocus lock* *Command dial*

■ **Protect image/AE-L/AF-L lock.** This triple-duty button can be used to protect an image from accidental erasure. When reviewing a picture on the LCD, press once to protect the image, a second time to unprotect it. A key symbol appears when the image is displayed to show that it is protected. (This feature safeguards an image from erasure when deleting or transferring pictures only; when you format a card, protected images are removed along with all the others.) When shooting pictures, the button locks the exposure or focus that the camera sets when you partially depress the shutter button. The exposure lock indication (AE-L icon) appears in the viewfinder. If you want to recalculate exposure or autofocus with the shutter button still partially depressed, press the button again. The exposure/autofocus will be unlocked when you release the shutter button or take the picture. To retain the exposure/autofocus lock for subsequent photos, keep the button pressed while shooting.

■ **Command dial.** The command dial is used to set or adjust many functions, such as shutter speed, either alone or when another button is depressed simultaneously.

You'll be using the four buttons to the left of the LCD monitor (shown in Figure 2.4) quite frequently.

■ **LCD.** View your images and navigate through the menus on this screen.

■ **Playback button.** Press this button to review images you've taken, using the controls and options I'll explain in the next section. To remove the displayed image, press the Playback button again, or simply tap the shutter release button.

Figure 2.4

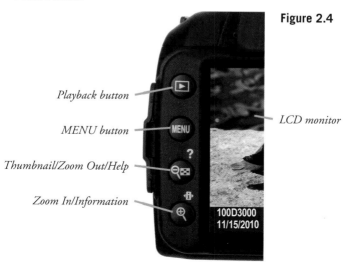

Playback button

MENU button

Thumbnail/Zoom Out/Help

Zoom In/Information

LCD monitor

100D3000
11/15/2010

■ **MENU button.** Summons/exits the menu displayed on the rear LCD of the D3000. When you're working with submenus, this button also serves to exit a submenu and return to the main menu.

■ **Thumbnail/Zoom Out/Help button.** In Playback mode, use this button to change from full-screen view to six or nine thumbnails, or to zoom out. I'll explain zooming and other playback options in the next section. When viewing most menu items on the LCD, pressing this button produces a concise Help screen with tips on how to make the relevant setting.

■ **Zoom In/Information edit button.** In Playback mode, press to zoom in on an image. When shooting pictures, press this button to restore the shooting information display; press a second time to produce the information edit screen used to make many camera settings, such as metering mode, white balance, or ISO. Press this button to activate the shooting information display. Press again to remove the information display (or simply tap the shutter release button). The display will also clear after the period you've set for LCD display (the default value is 20 seconds). The information display can be set to alternate between modes that are best viewed under bright daylight, as well as in dimmer illumination.

More controls reside on the right side of the back panel, as shown in Figure 2.5. The key controls and their functions are as follows:

■ **Multi selector.** This joypad-like button can be shifted up/down and side to side to provide several functions, including AF point selection, scrolling around a magnified image, or trimming a photo. Within menus, pressing the up/down buttons moves the on-screen cursor up or down; pressing towards the right selects the highlighted item and displays its options; pressing left cancels and returns to the previous menu.

■ **OK button.** Use this button to confirm a selection. When working with menus, press the MENU button instead to back out without making a selection.

■ **Access lamp.** When lit or blinking, this lamp indicates that the memory card is being accessed.

■ **Trash.** Press to erase the image shown on the LCD. A display will pop up on the LCD asking you to press the Trash button once more to delete the photo, or press the Playback button to cancel.

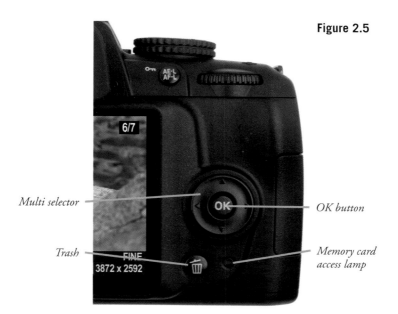

Figure 2.5

Multi selector

OK button

Trash

Memory card
access lamp

Playing Back Images

Here are the basics involved in reviewing images on the LCD screen (or on a television screen you have connected with a cable).

- **Start review.** To begin review, press the Playback button at the upper-left corner of the back of the D3000. The most recently viewed image will appear on the LCD.

- **Playback folder.** Image review generally shows you the images in the currently selected folder on your memory card. A given card can contain several folders (a new one is created anytime you exceed 999 images in the current folder). You can use the Playback folder menu option in the Playback menu (as I'll explain in Chapter 3) to select a specific folder, or direct the D3000 to display images from all the folders on the memory card.

- **View thumbnail images.** To change the view from a single image to four or nine thumbnails, follow the instructions in the "Viewing Thumbnails" section that follows.

- **Zoom in and out.** To zoom in or out, press the Zoom In or Zoom Out buttons, following the instructions in the "Zooming the Nikon D3000 Playback Display" in the next section. (It also shows you how to move the zoomed area around using the multi selector pad.)

- **Move back and forth.** To advance to the next image, rotate the command dial to the right or press the right edge of the multi selector pad; to go back to a previous shot, rotate the command dial to the left or press the left edge of the multi selector. When you reach the beginning/end of the photos in your folder, the display "wraps around" to the end/beginning of the available shots.

- **See different types of data.** To change the type of information about the displayed image that is shown, press the up and down portions of the multi selector pad. To learn what data is available, read the "Working with Photo Information" section later in this chapter.

- **Retouch image.** Press the OK button while a single image is displayed on the screen to jump to the Retouch menu to modify that photograph. (I'll explain the workings of the Retouch menu in Chapter 3.)

- **Remove images.** To delete an image that's currently on the screen, press the Trash button once, and then press it again to confirm the deletion. To select and delete a group of images, use the **Delete** option in the Playback menu to specify particular photos to remove, as described in more detail in Chapter 3.

- **Cancel playback.** To cancel image review, press the Playback button again, or simply tap the shutter release button.

Zooming the Nikon D3000 Playback Display

Here's how to zoom in and out on your images during picture review:

1. When an image is displayed (use the Playback button to start), press the Zoom In button to fill the screen with a slightly magnified version of the image. You can keep pressing the Zoom In button to magnify a portion of the image up to 25X if you used the Large resolution setting when shooting the photo. An image at Medium resolution can be magnified up to 19X, while Small images can be zoomed in up to 13X. (See Figure 2.6, top.)

2. A navigation window appears in the lower-right corner of the LCD showing the entire image. Keep pressing to continue zooming in.

3. A yellow box in the navigation window shows the zoomed area within the full image. The entire navigation window vanishes from the screen after a few seconds, leaving you with a full-screen view of the zoomed portion of the image.

4. Use the command dial to move to the same zoomed area of the next/previous image.

Figure 2.6

5. Use the Zoom Out/Thumbnail button to zoom back out of the image.

6. Use the multi selector buttons to move the zoomed area around within the image. The navigation window will reappear for reference when zooming or scrolling around within the display.

7. To exit Zoom In/Zoom Out display, keep pressing the Zoom Out button until the full-screen/full-image/information display appears again. If you continue pressing the Zoom Out button from the full-screen view, you'll be shown four, nine, and 72 thumbnails, plus a Calendar view. These are all described in the next section. (See Figure 2.6, bottom.)

Viewing Thumbnails

The Nikon D3000 provides other options for reviewing images in addition to zooming in and out. You can switch between single image view and either four, nine, or 72 reduced-size thumbnail images on a single LCD screen.

Pages of thumbnail images offer a quick way to scroll through a large number of pictures quickly to find the one you want to examine in more detail. The

D3000 lets you switch quickly from single- to four- to nine- to 72-image views, with a scroll bar displayed at the right side of the screen to show you the relative position of the displayed thumbnails within the full collection of images in the active folder on your memory card. Figure 2.6 (bottom) offers a comparison between the three levels of thumbnail views: four thumbnails (bottom left), nine thumbnails (bottom center), or 72 thumbnails (bottom right). The Zoom In and Zoom Out/Thumbnail buttons are used.

- **Add thumbnails.** To increase the number of thumbnails on the screen, press the Zoom Out button. The D3000 will switch from single image to four thumbnails to nine thumbnails to 72 thumbnails, and then to Calendar view (discussed next). Additional presses in Calendar view toggles back and forth between highlighting calendar dates, or showing pictures taken on that date (see "Working with Calendar View," next). (The display doesn't cycle back to single image again.)

- **Reduce number of thumbnails.** To decrease the number of thumbnails on the screen, press the Zoom In button to change from Calendar view to 72 to nine thumbnails to four thumbnails, or from four to single-image display. Continuing to press the Zoom In button once you've returned to single-image display starts the zoom process described in the previous section.

- **Change highlighted thumbnail area.** Use the multi selector to move the yellow highlight box around among the thumbnails.

- **Protect and delete images.** When viewing thumbnails or a single-page image, press the Protect button to preserve the image against accidental deletion (a key icon is overlaid over the full-page image) or the Trash button (twice) to erase it.

- **Exit image review.** Tap the shutter release button or press the Playback button to exit image review. You don't have to worry about missing a shot because you were reviewing images; a half-press of the shutter release automatically brings back the D3000's exposure meters, the autofocus system, and cancels image review.

Working with Calendar View

Once in Calendar view, you can sort through images arranged by the date they were taken. This feature is especially useful when you're traveling and want to see only the pictures you took in, say, a particular city on a certain day.

- **Change dates.** Use the multi selector keys or main dial and sub-command dial to move through the date list. If your memory card has pictures taken on a highlighted date, they will be arrayed in a scrolling list at the right side of the screen (see Figure 2.7).

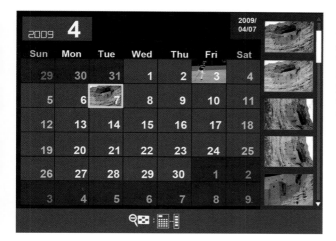

Figure 2.7
Calendar view
allows you to
browse through
all images on
your memory
card taken on a
certain date.

- **View a date's images.** Press the Zoom In button to toggle between the date list to the scrolling thumbnail list of images taken on that date. When viewing the thumbnail list, you can use the multi selector up/down keys to scroll through the available images.

- **Preview an image.** In the thumbnail list, when you've highlighted an image you want to look at, press the Zoom In button to see an enlarged view of that image without leaving the Calendar view mode. The zoomed image replaces the date list.

- **Delete images.** Pressing the Trash button deletes a highlighted image in the thumbnail list. In the Date List view, pressing the Trash button removes all the images taken on that date (use with caution!).

- **Exit Calendar view.** In Thumbnail view, if you highlight an image and press the OK button, you'll exit Calendar view and the highlighted image will be shown on the LCD in the display mode you've chosen. (See "Working with Photo Information" to learn about the various display modes.) In Date List view, pressing the Zoom In button exits Calendar view and returns to 72 thumbnails view. You can also exit Calendar view by tapping the shutter release (to turn off the LCD to ready the camera for shooting) or by pressing the MENU button.

Working with Photo Information

When reviewing an image on the screen, your D3000 can supplement the image itself with a variety of shooting data, ranging from basic information presented at the bottom of the LCD display, to three text overlays that detail virtually every

shooting option you've selected. This section will show you the type of information available. Most of the data is self-explanatory, so the labels in the accompanying figures should tell you most of what you need to know. To change to any of these views while an image is on the screen in Playback mode, press the multi selector up/down buttons (unless you've swapped the up/down functions with the left/right functions in the Custom Setting menu).

- **File information screen.** The basic full-image review display is officially called the file information screen, and looks like Figure 2.8.

- **RGB histogram.** This shows the image accompanied by a brightness histogram, as well as red, green, and blue histograms, which you can see in Figure 2.9. The histogram is a kind of chart that represents an image's exposure, and how the darkest areas, brightest areas, and middle tones have been captured.

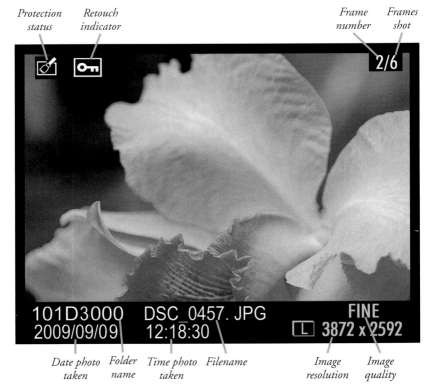

Figure 2.8 File information screen.

- **Highlights.** When the Highlights display is active (see Figure 2.10), any overexposed areas will be indicated by a flashing black border. As I am unable to make the printed page flash, you'll have to check out this effect for yourself.

- **Shooting Data 1.** This screen tells you everything else you might want to know about a picture you've taken, including metering mode, exposure mode, exposure compensation, lens information, and all the details of any built-in or external dedicated flash units you might have used. I'm not providing any labels in Figure 2.11, because the information in the first eight

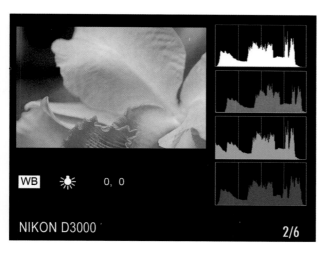

Figure 2.9
RGB histogram screen.

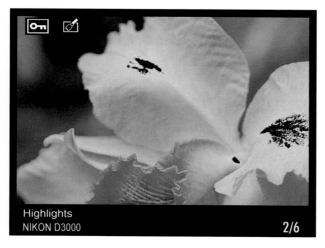

Figure 2.10
Highlights display.

lines in the screen should be obvious as you read about metering, exposure modes, lens focal lengths, and flash modes in this book.

■ **Shooting Data 2.** This screen shows white balance data and adjustments, sharpness and saturation settings, and other parameters (see Figure 2.12).

■ **Shooting Data 3.** This screen shows noise reduction information, Active D-Lighting, retouching effects that have been applied, and your user comments, as shown in Figure 2.13.

■ **Overview data.** This screen adds more data, including metering mode, shutter speed, f/stop, and ISO setting, and looks like Figure 2.14.

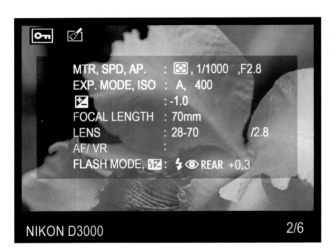

Figure 2.11
Shooting Data 1 screen.

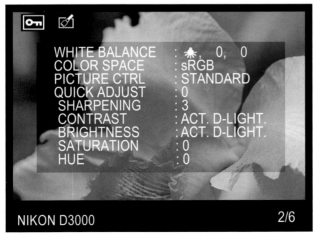

Figure 2.12
Shooting Data 2 screen.

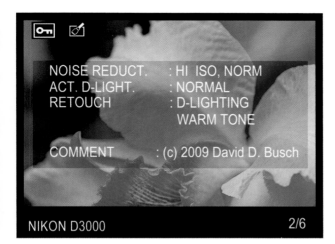

Figure 2.13
Shooting Data 3 screen.

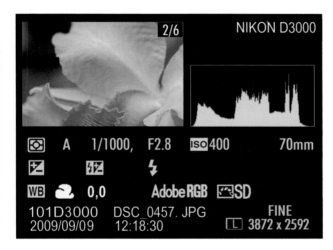

Figure 2.14
Overview data screen.

Shooting Information Display/Information Edit Screen

The back-panel color LCD can be used to provide a wealth of information (the shooting information display) and access to a number of settings (the information edit screen). The information edit screen can help you avoid some trips to Menuland, by making some basic adjustments available using the color LCD's speedy settings view.

To activate/deactivate the shooting information display, press the Info button on top of the camera (which just turns the display on or off), or press the information edit button on the back of the camera, near the bottom-left corner of the color LCD. (That button also allows you to *change* some of the settings.) When the screen is visible, you'll see settings like those shown in Figure 2.15. Two versions are available: the "Classic" version (left), which has a clean, text-based format, and the "Graphic" version (right), which includes a smattering of graphics—particularly in Scene modes, when a representation of the mode dial appears briefly as you change modes. Use the Auto information display from the Setup menu to specify which of these two versions to use. You can choose the display type for Auto/Scene modes and advanced modes separately, while choosing a blue, black, or orange color scheme. Light-on-dark is usually easier to read in dim lighting conditions, while the reverse scheme is better under bright lighting.

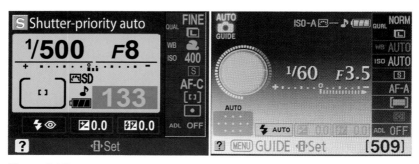

Figure 2.15 The shooting information display shows basic information on the color LCD.

When the shooting information display is shown, press the information edit button a second time to activate the information edit menu at the bottom of the screen, shown in Figure 2.16. Use the multi selector left/right buttons to highlight one of the adjustments, then press the OK button to produce a screen of options for that setting. You'll find the information edit screen can be much faster to use for setting ISO noise reduction, adjusting Active D-Lighting, or accessing a Picture Control. You'll find full explanations of these features in Chapter 3.

The shooting information displayed on the LCD displays status information about most of the shooting settings. Some of the items on the status LCD also appear in the viewfinder, such as the shutter speed and aperture and the expo-

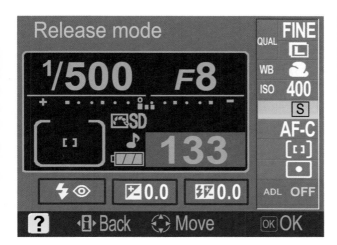

Figure 2.16
Information edit
can be accessed
by a second press
of the informa-
tion edit button.

sure level. This display remains active for about eight seconds, then shuts off if
no operations are performed with the camera, or if the eye sensor detects that
you're looking through the viewfinder. The display also turns off when you press
the shutter release halfway. You can re-activate the display by pressing the Zoom
In/Info, Zoom Out, D-Lighting, or Self-timer/Fn buttons (except when the
behavior of the latter button has been set to white balance compensation). The
display also appears when the exposure compensation/aperture button is pressed
in P, S, or A exposure modes, or when the Flash button is pressed in any expo-
sure mode other than Auto (Flash Off). In other words, the shooting informa-
tion display appears whenever you're likely to need it, and can be summoned at
other times by pressing the Zoom In/information edit button. (Remember, you
can press the button a second time to access the information edit screen.)

- **Exposure mode.** This indicator tells you whether the D3000 is set for one
 of the Scene modes, or for Program, Shutter-priority, Aperture-priority, or
 Manual exposure modes. An asterisk appears next to the P when you have
 used Flexible Program mode, which allows you to depart from the camera's
 programmed exposure setting to set a different combination of shutter
 speed/aperture that produces the same exposure. You'll find more about this
 feature in Chapter 4.

- **Image size.** Shows whether the D3000 is shooting Large (3872 × 2592 pix-
 els), Medium (2896 × 1944 pixels), or Small (1926 × 1296 pixels) sizes.

- **Image quality.** Shows current image quality, including JPEG, RAW, and
 RAW+Basic.

- **White balance setting.** One of the white balance settings will appear here, depending on the selection you've made.

- **Shooting mode.** Indicates whether the D3000 is set for Single frame, Continuous, or one of the Self-timer/Remote modes.

- **Focus mode.** Shows AF-C, AF-S, AF-A, and Manual focus modes.

- **Autofocus-area indicator.** Displays the autofocus area status, from among Single point, Dynamic Area, Auto-area, and 3D-tracking (11 points), all discussed earlier.

- **Metering mode.** Indicates whether Matrix, Center-weighted, or Spot metering has been selected.

- **ISO Auto indicator.** Displayed when you've set the D3000 to adjust ISO for you automatically.

- **Electronic analog display/additional functions.** This is a continuous scale that shows that correct exposure is achieved when the indicator is in the center, and how many stops off exposure is when the indicator veers to the right (underexposure) or left (overexposure). This scale is also used to display other information, such as exposure compensation.

- **Exposure compensation.** Appears when you've dialed in exposure compensation. Monitor this indicator, as it's easy to forget that you've told the Nikon D3000 to use more or less exposure than what its (reasonably intelligent) metering system would otherwise select.

- **Flash compensation.** Reminds you that you've tweaked the D3000's electronic flash exposure system with more or less exposure requested.

- **Number of exposures/additional functions.** This indicator shows the number of exposures remaining on your memory card, as well as other functions, such as the number of shots remaining until your memory buffer fills.

- **Battery status.** Three segments show the approximate battery power remaining.

- **Flash mode.** The current mode for the D3000's built-in electronic flash unit is shown here.

- **Active D-Lighting status.** Shows whether this feature is active or turned off.

- **Beep indicator.** Indicates that a helpful beep will sound during the countdown in Self-timer or Delayed remote mode, or just once in Quick-response remote mode. The beep also chirps when the D3000 successfully focuses when using Sports scene mode, as well as in AF-S or AF-A autofocus modes. No beep sounds in AF-C mode, or when the subject is moving while in AF-A mode (because the D3000 effectively switches to AF-C mode at that point).

- **Aperture/additional functions.** The selected f/stop appears here, along with a lot of other alternate information, as shown in the label in the Figure 2.16.

- **Shutter speed/additional functions.** Here you'll find the shutter speed, ISO setting, color temperature, and other useful data.

- **Help indicator.** Press the Help button to receive more information about a setting.

- **Change settings.** Press the information edit button while this screen is displayed to access the information edit screen.

Going Topside

The top surface of the Nikon D3000 (see Figure 2.17) has its own set of frequently accessed controls.

- **Accessory/flash shoe.** Slide an electronic flash into this mount when you need a more powerful Speedlight. A dedicated flash unit, like the Nikon SB-400, SB-600, SB-700, SB-900, or the SU-800 triggering device, can use the multiple contact points shown to communicate exposure, zoom setting, white balance information, and other data between the flash and the camera.

- **Power switch.** Rotate this switch clockwise to turn on the Nikon D3000 (and virtually all other Nikon dSLRs).

- **Info/Information button.** This button turns the shooting information display on or off.

- **Shutter release button.** Partially depress this button to lock in exposure and focus. Press all the way to take the picture. Tapping the shutter release when the camera has turned off the autoexposure and autofocus mechanisms reactivates both. When a review image is displayed on the back-panel color LCD, tapping this button removes the image from the display and reactivates the autoexposure and autofocus mechanisms.

- **Exposure compensation/Aperture button.** Press this button while spinning the command dial to change the aperture in Manual exposure mode (there is no need to press the button to change the aperture in Aperture-priority mode). Hold down this button and spin the command dial to add or subtract exposure when using Program, Aperture-priority, or Shutter-priority modes. This facility allows you to "override" the settings the camera has made and create a picture that is lighter or darker. This is called

Figure 2.17

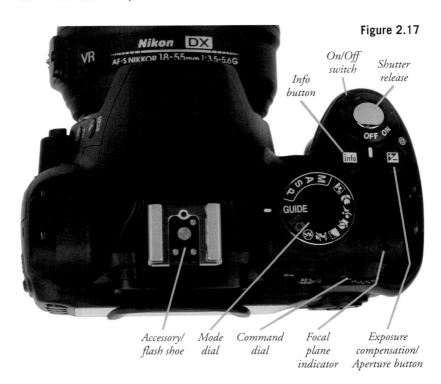

On/Off switch

Shutter release

Info button

Accessory/ flash shoe

Mode dial

Command dial

Focal plane indicator

Exposure compensation/ Aperture button

exposure compensation. Finally, the button can be used in conjunction with the flash button on the front of the camera to set flash exposure compensation. Hold down both buttons and spin the command dial to adjust the amount of flash exposure.

■ **Focal plane indicator.** This indicator shows the *plane* of the sensor, for use in applications where exact measurement of the distance from the focal plane to the subject are necessary. (These are mostly scientific/close-up applications.)

■ **Mode dial.** Rotate the mode dial to choose between Program, Shutter-priority, Aperture-priority, and Manual exposure modes, as well as the Scene modes Auto, Auto (No Flash), Portrait, Landscape, Child, Sports, Close-up, and Night Portrait. Your choice will be displayed on the LCD and in the viewfinder, both described in the next sections. You can read more about the Scene modes in Chapter 1.

Lens Components

The lens shown at left in Figure 2.18 is a typical lens that might be mounted on the Nikon D3000. It is, in fact, the 18-55mm VR "kit" lens sometimes sold with the camera body. Unfortunately, this particular lens doesn't include all the common features found on the various Nikon lenses available for your camera, so I am including a second lens (shown at right in the figure) that *does* have more features and components. It's not a typical lens that a D3000 user might work with, however. This 17-35mm zoom is a pricey "pro" lens that costs about 1.5X as much as the entire D3000 camera. Nevertheless, it makes a good example. Components found on this pair of lenses include:

- **Filter thread.** Most lenses have a thread on the front for attaching filters and other add-ons. Some, like the 18-55 VR kit lens, also use this thread for attaching a lens hood (you screw on the filter first, and then attach the hood to the screw thread on the front of the filter). Some lenses, such as the AF-S Nikkor 14-24mm f/2.8G ED lens, have no front filter thread, either because their front elements are too curved to allow mounting a filter and/or because the front element is so large that huge filters would be prohibitively expensive. Some front-filter-hostile lenses allow using smaller filters that drop into a slot at the back of the lens.

- **Lens hood bayonet.** Lenses like the 17-35mm zoom shown in the figure use this bayonet to mount the lens hood. Such lenses generally will have a dot on the edge showing how to align the lens hood with the bayonet mount.

- **Focus ring.** This is the ring you turn when you manually focus the lens, or fine-tune autofocus adjustment. It's a narrow ring at the very front of the lens (on the 18-55mm kit lens), or a wider ring located somewhere else.

- **Focus scale.** This is a readout found on many lenses that rotates in unison with the lens's focus mechanism to show the distance at which the lens has been focused. It's a useful indicator for double-checking autofocus, roughly evaluating depth-of-field, and for setting manual focus guesstimates.

- **Zoom setting.** These markings on the lens show the current focal length selected.

- **Zoom ring.** Turn this ring to change the zoom setting.

- **Autofocus/Manual switch.** Allows you to change from automatic focus to manual focus.

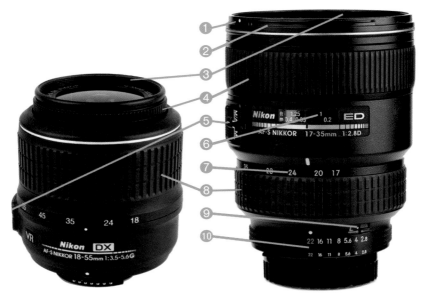

① *Lens hood alignment indicator*
② *Lens hood bayonet*
③ *Filter thread*
④ *Focus ring*
⑤ *Autofocus/Manual focus switch*
⑥ *Focus scale*
⑦ *Zoom setting*
⑧ *Zoom ring*
⑨ *Aperture lock*
⑩ *Aperture ring*

Figure 2.18

■ **Aperture ring.** Some lenses have a ring that allows you to set a specific f/stop manually, rather than use the camera's internal electronic aperture control. An aperture ring is useful when a lens is mounted on a non-automatic extension ring, bellows, or other accessory that doesn't couple electronically with the camera. Aperture rings also allow using a lens on an older camera that lacks electronic control. In recent years, Nikon has been replacing lenses that have aperture rings with versions that only allow setting the aperture with camera controls.

■ **Aperture lock.** If you want your D3000 (or other Nikon dSLR) to control the aperture electronically, on lenses with an aperture ring you must set the lens to its smallest aperture (usually f/22 or f/32) and lock it with this control.

■ **Focus limit switch.** Some lenses have a switch (not shown) that limits the focus range of the lens, thus potentially reducing focus seeking when shooting distant subjects. The limiter stops the lens from trying to focus at closer distances (in this case, closer than 2.5 meters).

■ **Vibration reduction switch.** Lenses with Nikon's Vibration Reduction (VR) feature include a switch for turning the stabilization feature on and off, and, in some cases, for changing from normal vibration reduction to a more aggressive "active" VR mode useful for, say, shooting from moving vehicles.

The back end of a lens intended for use on a Nikon camera has other components that you seldom see (except when you swap lenses), but still should know about:

■ **Lens bayonet mount.** This is the mounting mechanism that attaches to a matching mount on the camera. Although the lens bayonet is usually metal, some lenses use a rugged plastic for this key component.

■ **Automatic diaphragm lever.** This lever is moved by a matching lever in the camera to adjust the f/stop from wide open (which makes for the brightest view) to the *taking aperture*, which is the f/stop that will be used to take the picture. The actual taking aperture is determined by the camera's metering system (or by you when the D3000 is in Manual mode), and is communicated to the lens through the electronic contacts described next. (An exception is when the aperture ring on the lens itself is unlocked and used to specify the f/stop.) However, the spring-loaded physical levers are what actually push the aperture to the selected f/stop.

■ **Electronic contacts.** These metal contacts pass information to matching contacts in the camera body allowing a firm electrical connection so that exposure, distance, and other information can be exchanged between the camera and lens.

Looking Inside the Viewfinder

Much of the important shooting status information is shown inside the viewfinder of the Nikon D3000. Not all of this information will be shown at any one time. Figure 2.19 shows what you can expect to see. These readouts include:

■ **Focus points.** Can display the 11 areas used by the D3000 to focus. The camera can select the appropriate focus zone for you, or you can manually select one or all of the zones.

- **Active focus point.** The currently selected focus point can be highlighted with red illumination, depending on focus mode.
- **Battery indicator.** Appears when the D3000's battery becomes depleted.
- **Focus confirmation indicator.** This green dot stops blinking when the subject covered by the active autofocus zone is in sharp focus, whether focus was achieved by the AF system, or by you using manual focusing.

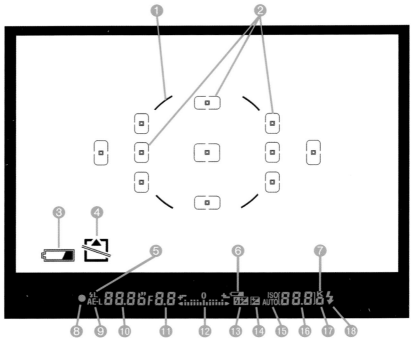

❶ Center-weighted circle
❷ Focus points
❸ Low battery warning
❹ No card warnings
❺ Flash value lock indicator
❻ Battery status
❼ Thousands of exposures remaining
❽ Focus confirmation indicator

❾ Autoexposure lock indicator
❿ Shutter speed
⓫ Aperture
⓬ Analog exposure display/Exposure compensation value
⓭ Flash exposure indicator
⓮ Exposure compensation indicator

⓯ ISO
⓰ Number of exposures remaining/Memory buffer shots/White balance recording/Exposure compensation value/Flash compensation value/Capture mode
⓱ ISO compensation indicator
⓲ Flash-ready

Figure 2.19

- **Autoexposure lock.** Shows that exposure has been locked.

- **Shutter speed.** Displays the current shutter speed selected by the camera, or by you in Manual exposure mode.

- **Aperture.** Shows the current aperture chosen by the D3000's autoexposure system, or specified by you when using Manual exposure mode.

- **Automatic ISO indicator.** Shown as a reminder that the D3000 has been set to adjust ISO sensitivity automatically. It flashes when the exposure meters are active as a warning to you that the camera may be adjusting the ISO setting.

- **Electronic analog exposure display.** This scale shows the current exposure level, with the bottom indicator centered when the exposure is correct as metered. The indicator may also move to the left or right to indicate over- or underexposure (respectively). The scale is also used to show the amount of exposure compensation dialed in.

- **Flash compensation indicator.** Appears when flash EV changes have been made.

- **Exposure compensation indicator.** This is shown when exposure compensation (EV) changes have been made. It's easy to forget you've dialed in a little more or less exposure, and then shoot a whole series of pictures of a different scene that doesn't require such compensation. Beware!

- **Flash-ready indicator.** This icon appears when the flash is fully charged.

- **Exposures remaining/maximum burst available.** Normally displays the number of exposures remaining on your memory card, but while shooting it changes to show a number that indicates the number of frames that can be taken in Continuous shooting mode using the current settings. This indicator also shows other information, such as exposure/flash compensation values, and whether the D3000 is connected to a PC through a USB cable.

Underneath Your Nikon D3000

There's not a lot going on with the bottom panel of your Nikon D3000. You'll find the battery compartment access door and a tripod socket, which secures the camera to a tripod. The socket accepts other accessories, such as flash brackets and quick release plates that allow rapid attaching and detaching of the D3000 from a matching platform affixed to your tripod.

Chapter 3

Playback and Shooting Menu Settings

The Playback and Shooting menus determine how the D3000 displays images on review, and how it uses many of its shooting features to take a photo. You'll find the Setup, Retouch, and Recent Settings options in Chapter 4.

Anatomy of the Nikon D3000's Menus

Press the MENU button, located third from the bottom at the left side of the LCD, to access the menu system. The most recently accessed menu will appear.

- **Top-level menus.** The left-hand column includes an icon representing each of the top-level menu screens. From the top in Figure 3.1, they are Playback (right-pointing triangle icon, blue coding), Shooting (camera icon, green coding), Setup (wrench, orange coding), Retouch (a paintbrush, purple coding), and Recent Settings (a tabbed page), with Help access represented by a question mark at the bottom of the column.

- **Menu functions.** The center column includes the name representing the function of each choice in the currently selected menu.

- **Current settings.** The right-hand column has an icon or text that shows either the current setting for that menu item or text or an icon that represents the function of that menu entry. In Figure 3.1, a trash can icon shows that you can use the **Delete** entry for removing images, while the text **OFF** appears next to the **Rotate tall** entry, indicating that the D3000 has been set to *not* rotate vertical images on the LCD.

Navigating among the various menus is easy and follows a consistent set of rules.

- **Press MENU to start.** Press the MENU button to display the main menu screens.

- **Navigate with the multi selector pad.** The multi selector pad, located to the right of the LCD, has indents at the up/down/left/right positions. Press these "buttons" to navigate among the menu selections. Press the left

button to move highlighting to the left column; then press the up/down buttons to scroll up or down among the five top-level menus.

- **Highlighting indicates active choice.** As each top-level menu is highlighted, its icon will first change from black-and-white to yellow/amber, white, and black. As you use the multi selector's right button to move into the column containing that menu's choices, you can then use the up/down buttons to scroll among the individual entries. If more than one screen full of choices is available, a scroll bar appears at the far right of the screen, with a position slider showing the relative position of the currently highlighted entry.

- **Select a menu item.** To work with a highlighted menu entry, press the OK button in the center of the multi selector on the back of the D3000 or just press the right button on the multi selector. Any additional screens of choices will appear. You can move among them using the same multi selector movements.

- **Choose your menu option.** You can confirm a selection by pressing the OK button or, frequently, by pressing the right button on the multi selector once again. Some functions require scrolling to a **Done** menu choice, or include an instruction to set a choice using some other button.

- **Leaving the menu system.** Pressing the multi selector left button usually backs you out of the current screen, and pressing the MENU button again usually does the same thing. You can exit the menu system at any time by tapping the shutter release button. If you haven't confirmed your choice for a particular option, no changes will be made.

- **Quick return.** The Nikon D3000 "remembers" the top-level menu and specific menu entry you were using (but not any submenus) the last time the menu system was accessed (even if you have subsequently turned off the camera), so pressing the MENU button brings you back to where you left off.

Playback Menu Options

The blue-coded Playback menu has nine entries used to select options related to the display, review, and printing of the photos you've taken. (The ninth, **Stop-motion movie** is not visible in Figure 3.1; it's scrolled off the bottom of the screen.) The choices you'll find include:

- Delete
- Playback folder
- Display mode
- Image review
- Rotate tall
- Slide show
- Print set (DPOF)
- Stop-motion movie

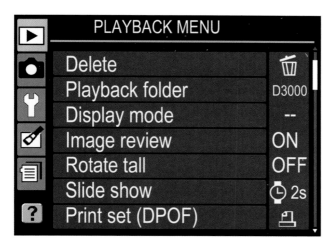

Figure 3.1
Playback menu.

Delete

Options: Selected, Select date, and All

Selected: You'll see an image selection screen like the one shown in Figure 3.2. Then, follow these instructions:

1. **Review thumbnails.** Use the multi selector left/right and up/down buttons to scroll among the available images.

2. **Examine image.** When you highlight an image you think you might want to delete, press the Zoom In button to temporarily enlarge that image so you can evaluate it further. When you release the button, the selection screen returns.

3. **Mark/unmark images.** To mark an image for deletion, press the Zoom Out/Index button (*not* the Trash button). A trash can icon will appear overlaid on that image's thumbnail. To unmark an image, press the Zoom Out/Index button again. Images marked with **Protect** cannot be selected for deletion. (See Figure 3.2.)

4. **Remove images.** When you've finished marking images to delete, press OK. A final screen will appear asking you to confirm the removal of the image(s). Choose **Yes** to delete the image(s) or **No** to cancel deletion, and then press OK. If you selected **Yes**, then you'll return to the Playback menu; if you chose **No**, you'll be taken back to the selection screen to mark/unmark images.

5. To back out of the selection screen, press the MENU button.

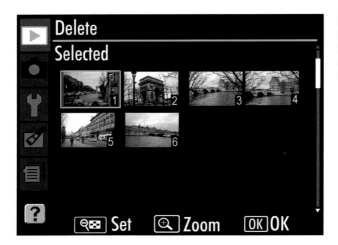

Figure 3.2
Images selected
for deletion are
marked with a
trash can icon.

Select Date: Highlight any of the available dates that have pictures, and press the multi selector right button to add a check mark to that date. Press the Zoom Out/Index button to view/confirm that the images for the date you've marked are those you want to delete, and press the button again to return to the **Select date** screen. When you're finished choosing dates, press OK to delete the images from the confirmation screen.

All: This removes all the "unprotected" images from your memory card. Keep in mind that **Format** is a faster way to remove images, but, unlike **All**, it deletes those marked as Protected as well.

Playback Folder

Options: Current, All

Images created by your Nikon D3000 are deposited into folders on your memory card. These folders have names like 100NCD3000 or 101NCD3000, but you can change those default names to something else using the **Active folder** option in the Setup menu, described later in Chapter 4.

With a freshly formatted memory card, the D3000 starts with a default name: 100NCD3000. When that folder fills with the maximum of 999 images, the camera automatically creates a new folder numbered one higher, such as 101NCD3000. If you use the same memory card in another camera, that camera will also create its own folder. This menu item allows you to choose

which folders are accessed when displaying images using the D3000's Playback facility.

- **Current.** The D3000 will display only images in the current folder, as specified in the Setup menu. You can change the current folder to any other specific folder on your memory card using the **Active folder** option in the Setup menu, described later in Chapter 4.

- **All.** All folders containing images that the D3000 can read will be accessed, regardless of which camera created them. You might want to use this setting if you swap memory cards among several cameras and want to be able to review all the photos. You will be able to view images even if they were created by a non-Nikon camera *if* those images conform to a specification called the Design Rule for Camera File systems (DCF).

Display Mode

Options: Highlights, RGB histogram, Data

This menu item helps you reduce/increase the color LCD clutter on playback by specifying which information and screens will be available. To activate or deactivate an info option, scroll to that option and press the right multi selector button to add a check mark to the box next to that item. Press the right button to unmark an item that has previously been checked. **Important:** when you're finished, you must scroll up to **Done** and press OK or the right multi selector button to confirm your choices. Exiting the Display mode menu any other way will cause any changes you may have made to be ignored. Your info options include:

- **Highlights.** When enabled, overexposed highlight areas in your image will blink with a black border during picture review. That's your cue to consider using exposure compensation to reduce exposure, unless a minus-EV setting will cause loss of shadow detail that you want to preserve.

- **RGB histogram.** Displays both luminance (brightness) and RGB histograms on a screen that can be displayed using the up/down multi selector buttons. When unmarked, this histogram screen is disabled, and only the **Overview data** screen, with the Brightness histogram, is displayed.

- **Data.** Activates/deactivates the three Shooting Data pages shown in Chapter 2.

Image Review

Options: On (default), Off

While instant review is useful, sometimes it's a better idea to *not* automatically review your shots in order to conserve battery power, speed up, or simplify operations. This menu operation allows you to choose which mode to use:

- **On.** Image review is automatic after every shot is taken.
- **Off.** Images are displayed only when you press the Playback button.

Rotate Tall

Options: On (default), Off

The D3000's internal directional sensor can detect whether the camera was rotated when the photo was taken and embed this information in the image file itself. It can be used by the D3000 to automatically rotate images when they are displayed on the camera's LCD monitor (providing a smaller image), or you can ignore the data and let the images display in non-rotated fashion (so you have to rotate the camera to view them in their larger, full-screen orientation). Your image-editing application can also use the embedded file data to automatically rotate images on your computer screen.

This works *only* if you've told the D3000 to place orientation information in the image file so it can be retrieved when the image is displayed. You must set **Auto image rotation** to **On** in the Setup menu, as described in Chapter 4. Then, both your D3000 and your image editor can rotate the images for you as the files are displayed.

This menu choice deals only with whether the image should be rotated when displayed on the *camera LCD monitor*. When **Rotate tall** is turned off, the Nikon D3000 does not rotate pictures taken in vertical orientation. The image is large on your LCD screen, but you must rotate the camera to view it upright. When **Rotate tall** is turned on, the D3000 rotates pictures taken in vertical orientation on the LCD screen so you don't have to turn the camera to view them comfortably. However, this orientation also means that the longest dimension of the image is shown using the shortest dimension of the LCD, so the picture is reduced in size.

Slide Show

Options: Start, Frame interval

The D3000's Slide show feature is a convenient way to review images in the current playback folder one after another, without the need to manually switch between them. It's faster to set up and use than Pictmotion, but doesn't have much in the way of options.

To activate a slide show, just choose **Start** from this entry in the Playback menu. If you like, you can choose **Frame interval** before commencing the show in order to select an interval of 2, 3, 5, or 10 seconds between "slides." During playback, you can press the OK button to pause the "slide show" (in case you want to examine an image more closely). When the show is paused, a menu pops up, as shown in Figure 3.3, with choices to restart the show (by pressing the OK button again); change the interval between frames; or to exit the show entirely.

As the images are displayed, press the up/down multi selector buttons to change the amount of information presented on the screen with each image. Press the left/right multi selector buttons to move back to a previous frame or jump ahead to the next one. Press the MENU button to exit the slide show and return to the menu, or the Playback button to exit the menu system totally. While reviewing images you can tap the MENU button to exit the show and return to the menus, or tap the shutter release button if you want to remove everything from the screen and return to shooting mode. At the end of the slide show, as when you've paused it, you'll be offered the choice of restarting the sequence, changing the frame interval, or exiting the slide show feature completely.

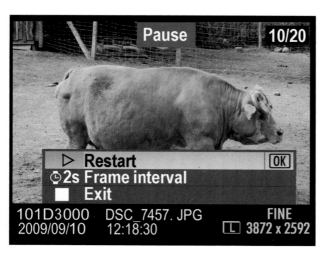

Figure 3.3

Select Pause/ Restart, Frame interval, or Exit and press the OK button.

Print Set (DPOF)

Options: Select/set, Deselect all

You can print directly from your camera to a printer compatible with a specification called *PictBridge*. You can mark images in the camera, and then remove your memory card and hand it to your retailer for printing in their lab or in-store printing machine, or insert the card into a standalone picture kiosk and make prints yourself. This menu lets you specify which photos you want printed, and how many copies you'd like of each picture. If you're taking photos in PSAM modes with the expectation of printing them through a direct USB connection, set **Color space** to **sRGB** for best results.

When you choose this menu item, you're presented with a set of screens that looks very much like the **Delete photos** screens described earlier, only you're selecting pictures for printing rather than deleting them. The first screen you see when you choose **Print set (DPOF)** asks if you'd like to **Select/set** pictures for printing, or **Deselect all?** images that have already been marked. Choose **Select/set** to choose photos and specify how many prints of each you'd like (see Figure 3.4). Choose **Deselect all?** to cancel any existing print order and start over.

1. **View images on your card.** Use the multi selector keys to scroll among the available images.

2. **Evaluate specific photos.** When you highlight an image you might want to print, press the Zoom In button to temporarily enlarge that image so you can evaluate it further. When you release the button, the selection screen returns.

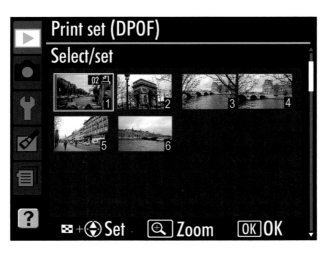

Figure 3.4
Select images for printing.

3. **Mark images for printing and specify number of copies.** To mark a high-lighted image for printing, hold the Zoom Out/Thumbnail button and press the multi selector up/down buttons to choose the number of prints you want, up to 99 per image. The up button increases the number of prints; the down button decreases the amount. A printer icon and the number specified will appear overlaid on that image's thumbnail.

4. **Unmark images if you change your mind.** To unmark an image for print-ing, highlight and press the Zoom Out/Thumbnail button and multi selec-tor down button until the number of prints reaches zero. The printer icon will vanish.

5. **Finish selecting and marking images.** When you've finished marking images to print, press OK.

6. **Specify date or shooting information on the print.** A final screen will appear in which you can request a data imprint (shutter speed and aperture) or imprint date (the date the photos were taken). Use the up/down buttons to select one or both of these options, if desired, and press the left/right but-tons to mark or unmark the check boxes. When a box is marked, the imprint information for that option will be included on *all* prints in the print order.

7. **Exit the Print Set screens.** Scroll up to **Done** when finished, and press OK or the right cursor button.

Stop-Motion Movie

Options: Select movie, Start/Pause/Resume, Advance/Rewind/Return to full frame playback

This menu entry allows you to display the stop-motion movie mini-films created in the Retouch menu. They consist of a series of frames that are displayed quickly, one after another, in flipbook or rough movie fashion. I'll explain how to *create* stop-motion movies later in this chapter. The **Stop-motion movie** menu choice in the Playback menu is grayed out (inaccessible) unless you have one or more of these movies stored in your current playback folder. There isn't much in the way of options for this menu entry; you can select a movie and play it.

If **Stop-motion movie** is not grayed out, select it and you'll see the Nikon D3000's image selection screen, but the thumbnails shown represent the first frame of each movie. Use the multi selector left/right buttons to navigate to the thumbnail of the movie you want to view. Then, press the Zoom button to see a slightly enlarged thumbnail of the first frame, or press OK to start the movie.

During playback, a progress bar appears at the bottom of the screen along with a bar containing the standard VCR/DVD-player type Reverse/Pause-Play/Stop/Forward icons. Press the multi selector left/right buttons to choose one of those actions and the OK button to activate it.

Shooting Menu Options

These 15 settings are likely to be the most common settings changes you make. The first seven choices are shown in Figure 3.5.

- Reset shooting options
- Set Picture Control
- Image quality
- Image size
- White balance
- ISO sensitivity
- Active D-Lighting
- Color space
- Noise reduction
- Release mode
- Focus mode
- AF-area mode
- AF-assist
- Metering
- Built-in flash

Reset Shooting Options

Options: Yes, No

If you select **Yes,** the Shooting menu settings shown in Table 3.1 will be set to their default values. It has no effect on the settings in other menus, or any of the other camera settings. If that's what you want, try the Reset button located on the

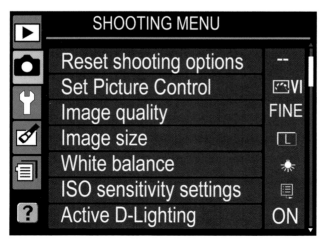

Figure 3.5
This is the first page of the Shooting menu.

Table 3.1 Values Reset

Setting	Default Value
Picture Controls	Varies by Picture Control
Focus Point	Center
Flexible Program	Off
AE-L/AF-L Hold	Off
Flash modes	Front Curtain Sync for Program, Aperture-priority, Shutter-priority, Manual modes; Auto Front Curtain Sync for Auto, Portrait, Child, Close-Up; Slow Sync for Night Portrait
Exposure Compensation	Off
Flash Compensation	Off

left side of the camera under the port cover. You'd want to use this Reset option when you've made a bunch of changes (say, while playing around with them as you read this chapter), and now want to put them back to the factory defaults.

Set Picture Control

Options: Standard, Neutral, Vivid, Monochrome, Portrait, Landscape, plus nine user-definable styles

Nikon provides six predefined styles (**Standard**, **Neutral**, **Vivid**, **Monochrome**, **Portrait**, and **Landscape**). However, you can *edit* the settings of any of those styles (but not rename them) so they better suit your taste. The D3000 also offers *nine* user-definable Picture Control styles that you can edit to your heart's content and assign descriptive names. You can *copy* these styles to a memory card, edit them on your computer, and reload them into your camera at any time. So, effectively, you can have a lot more than nine custom Picture Control styles available: the nine in your camera, as well as a virtually unlimited library of user-defined styles that you have stored on memory cards. These Picture Controls are available when you're using PSAM exposure modes.

Nikon insists that these styles have been standardized to the extent that if you re-use a style created for one camera (say, your D3000) and load it into a different compatible camera (such as a Nikon D3s), you'll get substantially the same rendition, so you can reproduce a film "style" like Fujifilm Velvia or use a style created by anyone else that you download from the internet.

Using and managing Picture Control styles is accomplished using two different menu entries, **Set Picture Control**, which allows you to choose an existing style and to edit the predefined styles that Nikon provides, and **Manage Picture Control**, which gives you the capability of creating and editing user-defined styles.

Choosing a Picture Control Style

In **Set Picture Control**, choose from one of the predefined styles and follow these steps:

1. Choose **Set Picture Control** from the Shooting menu. The screen shown in Figure 3.6 appears. Note that Picture Controls that have been modified from their standard settings have an asterisk next to their name.
2. Scroll down to the Picture Control you'd like to use.
3. Press OK to activate the highlighted style. (Although you can usually select a menu item by pressing the multi selector right button; in this case, that button activates editing instead.)
4. Press the MENU button or tap the shutter release to exit the menu system.

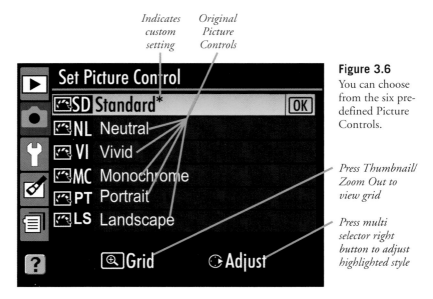

Indicates custom setting

Original Picture Controls

Figure 3.6
You can choose from the six predefined Picture Controls.

Press Thumbnail/ Zoom Out to view grid

Press multi selector right button to adjust highlighted style

Editing a Picture Control Style

You can change the parameters of any of Nikon's predefined Picture Controls. You are given the choice of using the quick adjust/fine-tune facility to modify a Picture Control with a few sliders, or to view the relationship of your Picture Controls on a grid. To make quick adjustments to any Picture Control except the Monochrome style, follow these steps:

1. Choose **Set Picture Control** from the Shooting menu.
2. Scroll down to the Picture Control you'd like to edit.
3. Press the multi selector right button to produce the adjustment screen shown in Figure 3.7.
4. Use the Quick Adjust slider to exaggerate the attributes of the **Standard**, **Vivid**, **Portrait**, or **Landscape** styles (Quick adjustments are not available with other predefined styles).
5. Scroll down to the Sharpening, Contrast, Saturation, and Hue sliders with the multi selector up/down buttons, then use the left/right buttons to decrease or increase the effects. A line will appear under the original setting in the slider whenever you've made a change from the defaults.
6. Instead of making changes with the slider's scale, you can move the cursor to the far left and choose A (for auto) instead when working with the Sharpening, Contrast, and Saturation sliders. The D3000 will adjust these parameters automatically, depending on the type of scene it detects.
7. Press the Trash button to reset the values to their defaults.
8. Press the Zoom In button to view an adjustment grid (discussed next).
9. Press OK when you're finished making adjustments.

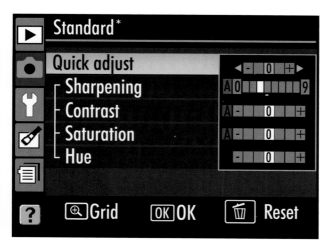

Figure 3.7
Sliders can be used to make quick adjustments to your Picture Control styles.

Editing the Monochrome style is similar, except that the parameters are Sharpening, Contrast, Brightness, Filter Effects (Yellow, Orange, Red, Green, or none) as well as toning effects (black-and-white, plus seven levels of Sepia, Cyanotype, Red, Yellow, Green, Blue Green, Blue, Purple Blue, and Red Purple). (Keep in mind that once you've taken a JPEG photo using a Monochrome style, you can't convert the image back to full color. Shoot using RAW+JPEG, and you'll get a monochrome JPEG, plus the RAW file that retains all the color information.) **Filter effects** produce a grayscale image that looks as if it were shot with black-and-white film using a color filter on the lens (no color tone is produced). **Toning effects** give you a tinted monochrome filter in various colors. (See Figure 3.8.)

When you press the Thumbnail/Zoom Out button, a grid display, like the one shown in Figure 3.9, appears showing the relative contrast and saturation of each of the predefined Picture Controls. If you've created your own custom Picture Controls, they will appear on this grid, too, represented by the numbers 1-9. Because the values for autocontrast and autosaturation may vary, the icons for any Picture Control that uses the Auto feature will be shown on the grid in green, with lines extending up and down from the icon to tip you off that the position within the coordinates may vary from the one shown.

Figure 3.8 Filter effects (left) produce grayscale images with varying tonal renditions; Toning effects (right) create tinted monochrome images.

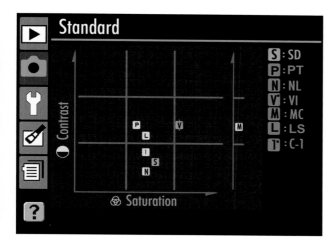

Figure 3.9
This grid shows the relationship of the Picture Controls being used.

Image Quality

Options: JPEG Fine, JPEG Normal, JPEG Basic, RAW, RAW+Basic

You can choose the image quality settings used by the D3000 to store its files. Just press the QUAL button and rotate the main command dial to scroll through the image quality (JPEG compression level) settings and the sub-command dial to choose the image size (resolution). You can also use this menu option and the next one, if you prefer. You have two choices to make:

- **Level of JPEG compression.** Compacting images reduces the quality a little, so you're offered your choice of **Fine** (a 1:4 reduction), **Normal** (1:8 reduction), and **Basic** (1:16) compression.

- **JPEG, RAW, or both.** You can elect to store only JPEG versions of the images you shoot, or you can save your photos as RAW images, which Nikon calls NEF, for Nikon Electronic Format files. RAW images consume more than twice as much space on your memory card. Or, you can store both RAW and JPEG Basic files at once as you shoot.

To choose the combination you want, access the Shooting menu, scroll to **Image quality**, and select it by pressing OK or the multi selector right button. Scroll to highlight the setting you want, and either press OK or push the multi selector right button to confirm your selection. In practice, you'll probably use the **JPEG Fine** or **NEF (RAW)+JPEG Basic** selections most often. However, settings that are less than max allow stretching the capacity of your memory card so you can shoehorn quite a few more pictures onto a single memory card, but

for most work, using lower resolution and extra compression is false economy. You never know when you might actually need that extra bit of picture detail. Instead, have enough memory cards for the images you plan to shoot.

Image Size

Options: Large, Medium, Small

The next menu command in the Shooting menu lets you select the resolution, or number of pixels captured as you shoot with your Nikon D3000. Your choices range from **Large** (L—3872 × 2592, 10.2 megapixels), **Medium** (M—2896 × 1944, 5.6 megapixels), and **Small** (S—1936 × 1296 pixels, 2.5 megapixels). There are no additional options available from the Image Size menu screen. Keep in mind that if you choose NEF (RAW) or NEW (RAW)+JPEG Basic, only the **Large** image size can be selected. The other size options are grayed out and unavailable.

White Balance

Options: Incandescent, Fluorescent, Direct Sunlight, Flash, Cloudy, Shade, PRE Preset manual

When you select the **White balance** entry on the Shooting menu, you'll see an array of choices like those shown in Figure 3.10. (One additional choice, **PRE Preset Manual** is not visible until you scroll down to it.) Choose the predefined value you want by pressing the multi selector right button, or press OK.

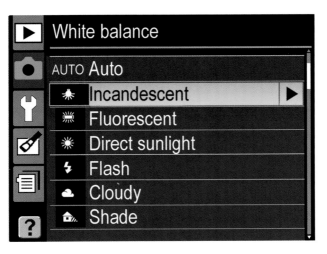

Figure 3.10
The White balance menu has predefined values, plus the option of setting a preset you measure yourself.

If you choose **Fluorescent**, you'll be taken to another screen that presents seven different types of lamps, from sodium-vapor through warm-white fluorescent down to high temperature mercury-vapor. If you know the exact type of non-incandescent lighting being used, you can select it, or settle on a likely compromise. Press the multi selector right button again or press OK to select the fluorescent lamp variation you want to use.

When you've finished choosing a fluorescent light source *and for all other prede-fined values*, (Auto, incandescent, direct sunlight, flash, cloudy, or shade), you'll next be taken to the fine-tuning screen shown in Figure 3.11 (and which uses the incandescent setting as an example). The screen shows a grid with two axes, a blue/amber axis extending left/right, and a green/magenta axis extending up and down the grid. By default, the grid's cursor is positioned in the middle, and a readout to the right of the grid shows the cursor's coordinates on the A-B axis (yes, I know the display has the end points reversed) and G-M axis at 0,0.

You can use the multi selector's up/down and right/left buttons to move the cursor to any coordinate in the grid, thereby biasing the white balance in the direction(s) you choose. The amber-blue axis makes the image warmer or colder (but not actually yellow or blue). Similarly, the green/magenta axis preserves all the colors in the original image, but gives them a tinge biased toward green or magenta. Each increment equals about five mired units, but you should know that mired values aren't linear; five mireds at 2,500K produces a much stronger

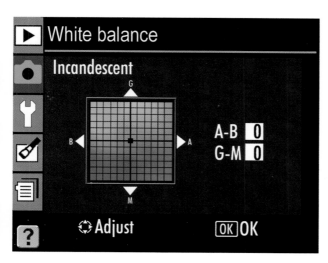

Figure 3.11
Specific white balance settings can be fine-tuned by changing their bias in the amber/blue, magenta/green directions—or along both axes simultaneously.

effect than five mireds at 6,000K. If you really want to fine-tune your color balance, you're better off experimenting and evaluating the results of a particular change.

When you've fine-tuned white balance, an asterisk appears next to the white balance icon in both the Shooting menu and shooting information screen shown on the LCD, as a tip-off that this tweaking has taken place.

Using Preset Manual White Balance

If automatic white balance or one of the predefined settings available aren't suitable, you can set a custom white balance using the **Preset manual** menu option. You can apply the white balance from a scene, either by shooting a new picture on the spot and using the resulting white balance (**Measure**), or using an image you have already shot (**Use photo**). To perform direct measurement from your current scene using a reference object (preferably a neutral gray or white object), follow these steps:

1. Place the neutral reference under the lighting you want to measure.

2. Choose **Preset manual** from the White balance screen in the Shooting menu (you may need to scroll down to see it).

3. Select **Measure** from the screen that appears by scrolling to it and pressing the multi selector right button or pressing **OK**.

4. A warning message appears, **Overwrite existing preset data?** Choose **Yes.**

5. An instructional message appears for a few seconds telling you to take a photo of a white or gray object that fills the viewfinder under the lighting that will be used for shooting. Do that!

6. After you've taken the photo, if the D3000 was able to capture the white balance data, a message **Data acquired** appears on the shooting information screen, and the PRE white balance setting is shown. If the D3000 was not able to capture white balance data, a pop-up message appears, and you should try again.

The preset value you've captured will remain in the D3000's memory until you replace that white balance with a new captured value. You can also use the white balance information from a picture you've already taken, using the **Use photo** option, as described next:

1. Choose **Preset manual** from the White balance menu.

2. Select **Use photo**.

3. The most recently shot picture will appear, with a menu offering to use **This image** or **Select image**.

4. Press OK to use the displayed image, or choose **Select image** to specify another picture on your memory card.

5. If you want to select a different image, you can choose which folder on your memory card, then navigate through the selected images, using the standard D3000 image selection screen shown several times previously in this chapter.

6. When the photo you'd like to use is highlighted, press OK to select it.

7. You'll be returned to the Shooting menu, where you can press the MENU button to exit, or just tap the shutter release.

ISO Sensitivity Settings

Options: ISO sensitivity, Auto ISO

The ISO setting feature governs how sensitive your D3000 is to light. Low ISO settings, such as ISO 100, provide better image quality, but mean that the camera must have more light available to take a picture, or that you must use wider lens openings or slower shutter speeds. Faster ISO settings let you take pictures in lower light levels, with faster shutter speeds (say, to freeze action) or with smaller lens openings (to produce a larger range in which objects are in sharp focus), but with an image quality and noise penalty.

This menu entry has two parts, ISO sensitivity (available with all exposure modes) and ISO sensitivity auto control (available only in PAS modes). The former is simply a screen that allows you to specify the ISO setting, just as you would by spinning the main command dial while holding down the ISO button on the back of the D3000. The available settings range from ISO 100 through HI 1 (ISO 3200 equivalent).

The ISO sensitivity auto control menu used with Program, Aperture-priority, and Shutter-priority (but not Manual) exposure modes lets you specify how and when the D3000 will adjust the ISO value for you automatically under certain conditions. When Auto ISO is activated, the camera can bump up the ISO sensitivity whenever an optimal exposure cannot be achieved at the current ISO setting.

■ **Off.** Set ISO sensitivity auto control to off, and the ISO setting will not budge from whatever value you have specified. Use this setting when you don't want any ISO surprises, or when ISO increases are not needed to counter slow shutter speeds. For example, if the D3000 is mounted on a tripod, you can safely use slower shutter speeds at a relatively low ISO setting, so there is no need for a speed bump.

■ **On.** At other times, you may want to activate the feature. For example, if you're hand-holding the camera and the D3000 set for Program (P) or Aperture-priority (A) mode wants to use a shutter speed slower than, say, 1/30th second, it's probably a good idea to increase the ISO to avoid the effects of camera shake. If you're using a telephoto lens (which magnifies camera shake), a shutter speed of 1/125th second or higher might be the point where an ISO bump would be a good idea. In that case, you can turn the ISO sensitivity auto control on, or remember to boost the ISO setting yourself.

■ **Maximum sensitivity.** If the idea of unwanted noise bothers you, you can avoid using an ISO setting that's higher than you're comfortable with. This parameter sets the highest ISO setting the D3000 will use in ISO-Auto mode. You can choose from ISO 200, 400, 800, and 1600 as the max ISO setting the camera will use. Use a low number if you'd rather not take any photos at a high ISO without manually setting that value yourself. Dial in a higher ISO number if getting the photo at any sensitivity setting is more important than worrying about noise.

■ **Minimum shutter speed.** You can decide the shutter speed that's your personal "danger threshold" in terms of camera shake blurring. That is, if you feel you can't hand-hold the camera at a shutter speed slower than 1/30th second, you can tell the D3000 that when the metered exposure will end up with a speed slower than that, ISO-Auto should kick in and do its stuff. When the shutter speed is *faster* (shorter) than the speed you specify, ISO-Auto will not take effect and the ISO setting you've set yourself remains in force. The default value is 1/30th second, because in most situations, any shutter speed longer/slower than 1/30th second is to be avoided, unless you're using a tripod, monopod, or looking for a special effect. If you're working with a telephoto lens and find even a relatively brief shutter speed "dangerous," you can set a minimum shutter speed threshold of 1/250th second.

Active D-Lighting

Options: Off (default), On

D-Lighting is a feature that improves the rendition of detail in highlights and shadows when you're photographing high contrast scenes (those that have dramatic differences between the brightest areas and the darkest areas that hold detail). Unlike the post-shot D-Lighting feature found in the Retouch menu, Active D-Lighting can be applied to your pictures *while you are actually taking the photo.*

For best results, use your D3000's Matrix metering mode, so the Active D-Lighting feature can work with a full range of exposure information from multiple points in the image. Active D-Lighting works its magic by subtly *underexposing* your image so that details in the highlights (which would normally be overexposed and become featureless white pixels) are not lost. At the same time, it adjusts the values of pixels located in midtone and shadow areas so they don't become too dark because of the underexposure. Highlight tones will be preserved, while shadows will eventually be allowed to go dark more readily. Bright beach or snow scenes, especially those with few shadows (think high noon, when the shadows are smaller), can benefit from using Active D-Lighting. Figure 3.12 shows a typical example.

You have just two choices: **Off** and **On**. You'll want to experiment to see which types of situations can benefit your shooting the most.

Figure 3.12
No D-Lighting (left); Active D-Lighting (right).

Color Space

Options: sRGB (default), Adobe RGB

The Nikon D3000's **Color space** option, the first entry on the second page of the Shooting menu (see Figure 3.13), gives you two different color spaces: **Adobe RGB** (because it was developed by Adobe Systems in 1998), and **sRGB** (supposedly because it is the *standard* RGB color space). Regardless of which color space is used by the D3000, you end up with some combination of 16.8 million different colors that can be seen in your photograph.

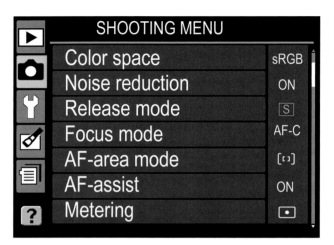

Figure 3.13
Second page of the Shooting menu.

Adobe RGB is an expanded color space useful for commercial and professional printing, and it can reproduce a wider range of colors. However, as an advanced user, you don't need to automatically "upgrade" your D3000 to Adobe RGB, because images tend to look less saturated on your monitor and, it is likely, significantly different from what you will get if you output the photo to your personal inkjet. (You can *profile* your monitor for the Adobe RGB color space to improve your on-screen rendition.) While both Adobe RGB and sRGB can reproduce the exact same 16.8 million absolute colors, Adobe RGB spreads those colors over a larger portion of the visible spectrum.

The sRGB space is recommended for images that will be output locally on the user's own printer, as it matches that of the typical inkjet printer fairly closely. It is well suited for the range of colors that can be displayed on a computer screen and viewed over the Internet. If you plan to take your image file to a retailer's kiosk for printing, sRGB is your best choice, because those automated output devices are calibrated for the sRGB color space that consumers use. If you shoot RAW or RAW+JPEG, with the camera set to one color space, you can extract the other from the RAW file at any time.

Noise Reduction

Options: Off (default), On

Visual noise is the graininess caused by long exposures and high ISO settings, and which shows up as multicolored specks in images. While noise reduction does minimize the grainy effect, it can do so at the cost of some sharpness. This

menu setting can be used to activate or deactivate the D3000's noise-canceling operation.

- **Off.** This default setting disables noise reduction. Use it when you want the maximum amount of detail present in your photograph, even though higher noise levels will result. This setting also eliminates the delay caused by the noise reduction process that occurs after the picture is taken (this delay is roughly the same amount of time that was required for the exposure). If you plan to use only lower ISO settings (thereby reducing the noise caused by high ISO values), the noise levels produced by longer exposures may be acceptable. For example, you might be shooting a waterfall at ISO 100 with the camera mounted on a tripod, using a neutral-density filter and a long exposure to cause the water to blur. (Try exposures of 2 to 16 seconds, depending on the intensity of the light and how much blur you want.) To maximize detail in the non-moving portions of your photos for the exposures that are eight seconds or longer, you can switch off long exposure noise reduction.

- **On.** When exposures are eight seconds or longer, the Nikon D3000 takes a second, blank exposure to compare that to the first image. (While the second image is taken, the warning **Job nr** appears in the viewfinder.) Noise (pixels that are bright in a frame that *should* be completely black) in the "dark frame" image is subtracted from your original picture, and only the noise-corrected image is saved to your memory card. Because the noise-reduction process effectively doubles the time required to take a picture, you won't want to use this setting when you're rushed. Some noise can be removed later on, using tools like Bibble Pro or the noise reduction features built into Nikon Capture NX.

Release Mode

Options: Single frame, Continuous, Self-timer, Delayed remote, Quick-response remote

The release mode determines when (and how often) the D3000 makes an exposure. You can choose one of these modes from the information edit screen, as described in Chapter 1, or specify a mode here. The D3000's five release (shooting) modes are as follows:

- **Single frame.** This is the default setting. One picture is taken every time you press the shutter release button down all the way. The Nikon D3000 operates so quickly, though, that you can easily take a series of shots in fast-moving situations simply by operating the shutter button rapidly.

■ **Continuous (burst).** When this setting is chosen, the D3000 takes a series of shots at approximately three frames per second for as long as you hold down the shutter release button, or until the camera's built-in memory (called a *buffer*) fills. When that happens, you must wait while pictures are transferred from the buffer to your memory card. As soon as some pictures are transferred, continuous shooting can resume. An indicator in the lower-right corner of the viewfinder shows how many more pictures the buffer can accept before the D3000's continuous shooting rate begins to slow. However, the D3000 can take a maximum of 100 pictures in continuous mode.

> ### 👍 Tip
>
> Continuous shooting mode is disabled when you are using flash; electronic flash can't recycle quickly enough to keep up with a three-frames-per-second burst of shots.

■ **Self-timer.** In this mode, the Nikon D3000 waits for a specified period of time after the shutter release is pressed before the picture is taken. You can set this delay to 2, 5, 10 (the default), or 20 seconds using **Self-timer delay** in the Setup menu (described later in this chapter). While the camera is counting down, the AF assist/self-timer lamp on the front of the camera blinks, until the last few seconds, when it remains on until the picture is finally taken. Remember that Nikon recommends attaching the eyepiece cap to the viewfinder eyepiece when shooting photos in this mode, or either of the two remote modes listed next. Light coming in the viewfinder can produce an incorrect exposure.

■ **Delayed remote.** Use this setting with the Nikon ML-L3 infrared remote control to trigger the camera to take a picture about two seconds after the D3000 has locked in focus.

■ **Quick-response remote.** With this setting, the D3000 takes a picture as soon as the button on the ML-L3 infrared remote control is pressed and the camera has achieved sharp focus.

Focus Mode

Options: AF-A, AF-C, AF-S

When using a non-Scene mode (Program, Shutter-priority, Aperture-priority, or Manual exposure), you can choose from among AF-A, AF-S, AF-C, or Manual focus modes. Each of these modes can be selected using the information edit

screen, as described in Chapter 1, or chosen here. The first three modes are available only when the autofocus switch on the D3000's lens is set to A (autofocus) or M/A (autofocus with manual override). To review the four modes:

■ **Auto select AF (AF-A).** When you press the shutter release halfway, the camera shifts into AF-S mode (as described below). If the subject begins to move, the D3000 changes to AF-C mode for as long as the subject continues its motion. This default mode is a good choice for general shooting when you don't know whether your subject will be stationary.

■ **Continuous-servo AF (AF-C).** When the D3000 is set to this mode, the camera sets focus when you partially depress the shutter button, but continues to monitor the frame and refocuses if the camera or subject is moved. This is a useful mode for photographing sports and moving subjects.

■ **Single-servo AF (AF-S).** In this mode, the Nikon D3000 locks in a focus point when the shutter button is pressed down halfway, and the focus confirmation light glows at bottom left in the viewfinder. The focus will remain locked until you release the button or take the picture. This mode is best when your subject is relatively motionless, because it is fast.

■ **Manual focus (M).** When the focus mode is set to manual, or when the switch on your lens is set to M, or you have mounted a lens that does not offer autofocus on your D3000, you always focus manually using the focus ring on the lens. The focus confirmation indicator in the viewfinder provides an indicator when correct focus is achieved. Lenses that don't provide autofocus features include lenses that do not have an autofocus motor built in. Nikon lenses with the AF-S designation in their name do have this autofocus motor; lenses labeled as AF do not. Don't confuse AF-S (so-called because they are autofocus lenses with a Nikon Silent-Wave motor) with the AF-S (Single-servo AF) mode. Older, manual focus lenses that totally lack AF features also must be focused manually (obviously).

AF-Area Mode

Options: Single point, Dynamic area, Auto-area, 3D-tracking (11 points)

This entry is a duplication of the autofocus area mode options in the information edit menu, as described in Chapter 1. To recap, the four choices are as follows:

■ **Single point.** You always choose which of the eleven points are used, and the Nikon D3000 sticks with that focus bracket, no matter what. This mode is best for non-moving subjects.

■ **Dynamic area.** You can choose which of the eleven focus zones to use, but the D3000 will switch to another focus mode when using AF-C or AF-A mode and the subject moves. This mode is great for sports or active children.

■ **Auto-area.** This default mode chooses the focus point for you, and can use distance information when working with a lens that has a G or D suffix in its name.

■ **3D-tracking (11 points).** You can select the focus zone, but when not using AF-S mode, the camera refocuses on the subject if you reframe the image.

AF-Assist

Options: On, Off

Use this setting to control whether the AF-assist lamp built into the Nikon D3000, or the more powerful AF-assist lamp built into Nikon electronic flash units (like the Nikon SB-800) and the Nikon SC-29 coiled remote flash cord (for firing the flash when not mounted on the camera) function in low light situations.

■ **On.** This default value will cause the AF-assist illuminator lamp to fire when lighting is poor, but only if Single-servo AF (AF-S) or Automatic AF (AF-A) are active, or you have selected the center focus point manually and either Single point or Dynamic area autofocus (rather than Auto-area autofocus) has been chosen. It does not operate in Manual focus modes, in AF-C mode, or when AF-A has switched to its AF-C behavior, nor when Landscape or Sports DVP/Scene modes are used.

> ### 👍 Tip
>
> With some lenses, the lens hood can block the AF-assist lamp's illumination; you may have to remove the hood in low-light situations.

■ **Off.** Use this to disable the AF-assist illuminator. You'd find that useful when the lamp might be distracting or discourteous (say, at a religious ceremony or acoustic music concert), or your subject is located closer than one foot, eight inches or farther than about 10 feet. One downside of turning AF-assist off is that the D3000 may be unable to focus accurately in situations where it really, really needs the extra light from the supplementary lamp. You may have to focus manually in such situations.

Metering

Options: Matrix, Center-weighted, Spot

This is a duplicate of the settings you can make from the information edit screen. As I explained in Chapter 1, the three modes are as follows:

■ **Matrix metering.** The standard metering mode; the D3000 attempts to intelligently classify your image and choose the best exposure based on readings from a 420-segment color CCD sensor that interprets light reaching the viewfinder using a database of hundreds of thousands of patterns.

■ **Center-weighted metering.** The D3000 meters the entire scene, but gives the most emphasis to the central area of the frame, measuring about 8mm in diameter.

■ **Spot metering.** Exposure is calculated from a smaller 3.5 mm central spot, about 2.5 percent of the image area.

Built-in Flash

Options: TTL, Manual

This setting is used to adjust the features of the Nikon D3000's built-in pop-up electronic flash. Its settings are in force when you are using Program, Shutter-priority, Aperture-priority, or Manual exposure modes (but not when using any of the Scene modes). You have two options with this setting:

■ **TTL.** When selected, the built-in flash (or when an optional unit like the SB-400 is connected to the accessory shoe on top of the camera) operate in iTTL (intelligent through the lens) exposure mode to automatically choose an exposure based on measuring the light from a "pre-flash" (fired an instant before the picture is taken) as it reflects back to the camera. Use this setting under most circumstances. The D3000 can even balance the flash output with the daylight or other illumination to allow the flash to fill in dark shadows or provide supplementary light.

■ **Manual.** In this mode, the flash always fires using a preselected output level, which ranges from full power to 1/32 power. Use this mode when you want a certain exposure for every shot, say, to deliberately under- or overexpose an image for a special effect.

Chapter 4

Setup, Retouch, and Recent Settings Menus

This chapter shows you how and why to use each of the options in the Setup, Retouch, and Recent Settings sections of your D3000's menu system.

Setup Menu Options

The orange-coded Setup menu (see Figure 4.1 for its first page) has a long list of 17 entries (or just 10 if you've enabled "simple" menus using the **CSM/Setup menu** option described below). In this menu you can make additional adjustments on how your camera *behaves* before or during your shooting session, as differentiated from the Shooting menu, which adjusts how the pictures are actually taken. Your choices include:

- Reset setup options
- Format memory card
- LCD brightness
- Info display format
- Auto info display
- Clean image sensor
- Mirror lock-up
- Video mode
- Time zone and date
- Language
- Image comment
- Auto image rotation
- Dust Off ref photo

- Auto off timers
- Self-timer delay
- Remote on duration
- Beep
- Viewfinder options
- File number sequence
- Buttons
- No memory card?
- Date imprint
- Active folder
- Eye-Fi upload (appears only when an Eye-Fi card is inserted)
- Firmware version

Figure 4.1
The first page of the Setup menu has seven entries.

Reset Setup Options

Options: Yes, No

If you select **Yes,** the Setup menu settings shown in Table 4.1 will be set to their default values. It has no effect on the settings in other menus, or any of the other camera settings. If that's what you want, try the Reset button located on the left side of the camera under the port cover.

You'd want to use this Reset option when you've made a bunch of changes (say, while playing around with them as you read this chapter), and now want to put them back to the factory defaults. Your choices are **Yes** and **No.** Note that **Video mode**, **Time zone and date**, **Language**, and **Active folder** are not reset.

Format Memory Card

Options: Yes, No

I recommend using this menu entry to reformat your memory card after each shoot to avoid stray files and to set up a fresh file system. To format a memory card, choose this entry from the Setup menu, highlight **Yes** on the screen that appears, and press OK.

LCD Brightness

Options: Auto dim (on/off), LCD brightness

Choose this menu option and you can choose to turn **Auto dim** on or off (the default is **On**), which causes the LCD brightness to decrease gradually while

Table 4.1 Values Reset

Setting	Default Value
LCD Brightness	0
Auto Dim	On
Info Display Format	Graphic; Green background
Auto Info Display	On
Clean Image Sensor	Startup & Shutdown
Time Zone and Date/ Daylight Saving Time	Off
Language	Varies by country of purchase
Auto Image Rotation	On
Auto Off Timers	Normal
Self-Timer Delay	10 seconds
Remote On Duration	Five Minutes
Beep	On
Viewfinder Options	Grid: Off ; Rangefinder: Off
File Number Sequence	Off
Buttons	Fn Button: Self-timer AE-L/AF-L:AE/AF Lock AE Lock: Off
No Memory Card	Release Locked
Data Imprint	Off
Eye-Fi Upload	Enable

shooting information is displayed, producing a slight decrease in power consumed. You can also choose to adjust the intensity of the display using the **LCD brightness** option. A grayscale strip appears on the LCD, as shown in Figure 4.2. Use the multi selector up/down keys to adjust the brightness to a comfortable viewing level over a range of +3 to –3. Under the lighting conditions that exist when you make this adjustment, you should be able to see all 10 swatches from black to white. If the two end swatches blend together, the brightness has been set too low. If the two whitest swatches on the right end of the strip blend together, the brightness is too high. Brighter settings use more battery power, but can allow you to view an image on the LCD outdoors in bright sunlight. When you have the brightness you want, press OK to lock it in and return to the menu.

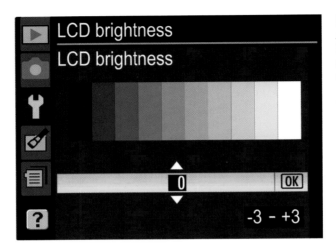

y

Figure 4.2
Adjust the LCD brightness so that all the grayscale strips are visible.

Info Display Format

Options: Auto/Scene modes/P,S,A,M modes: Classic (blue, black, orange), Graphic (white, black, orange)

You can choose the format the Nikon D3000 uses for its shooting information display. Three formats are available, and you can specify them separately for the camera's fully automated Scene modes, and for the semi-automated Program, Shutter-priority, Aperture-priority, and Manual exposure modes (collectively known as PSAM). The available modes are as follows:

- **Classic.** This is a mostly text-based format with a few icons, as shown at left in Figure 4.3. You'll find this format the fastest to use once you've grown accustomed to the D3000 and its features, as all the information is clustered in a no-nonsense way that is easy to read. I set both DVP and PSAM mode groups to this format.

- **Graphic.** This format mixes text and graphics, and includes a facsimile of the mode dial that appears briefly on the left side of the screen as you change from one exposure mode to the other. (See at right in Figure 4.3.)

You can change the shooting information display to the format of your choice using three easy-to-understand screens:

1. Choose **Info display format** from the Setup menu.
2. Select either **Auto/scene modes** or **P, S, A, M** and press the multi selector right button.
3. Choose either **Classic** or **Graphic** and press the multi selector right button.

Figure 4.3 The Classic information display (left) is clean and based mostly on text. The Graphic format (right) spices up the display with some graphical elements.

4. Specify a background color and press **OK**:
 Classic: Blue, Black, or Orange
 Graphic: White, Black, or Orange
5. You'll be returned to the first screen you saw, where you can again choose from **Auto/scene modes** or **P, S, A, M** or press the MENU button (or tap the shutter release) to exit.

Auto Info Display

Options: Auto/Scene modes: On, Off; PSAM modes: On, Off

This setting controls when the shooting information display is shown on the LCD. The display is a handy tool for checking your settings as you shoot. It does use up battery power, so you might want to turn off the automatic display if you don't need to review your settings frequently, or if you especially want to conserve battery power. The shooting information display can be viewed any time by pressing the Info button at the lower-left side of the back of the D3000. You can choose whether to display Auto/Scene modes or P, S, A, and M modes individually. Here's how this option works for both types of modes:

■ **On.** The D3000 will display the shooting information screen if the shutter release button is pressed halfway and released. If you've set **Image review** to **Off** in the Playback menu, the shooting information screen also appears as soon as the photograph is taken. If **Image review** is set to **On**, the shooting information screen appears only when the shutter release is pressed halfway and released, or if the Info button is pressed, but not immediately after the picture is taken. (Instead, the picture you just took is shown.)

■ **Off.** The shooting information screen is not displayed when you press the shutter release button halfway and release it. You can activate the display by pressing the Info button.

Clean Image Sensor

Options: Clean now, Clean at (ON, OFF, ON/OFF, Cleaning Off)

This entry gives you some control over the Nikon D3000's automatic sensor cleaning feature, which removes dust through a vibration cycle that shakes the sensor until dust, presumably, falls off and is captured by a sticky surface at the bottom of the sensor area. Access this menu choice, place the camera with its base downward, choose **Clean now**, and press OK. A message **Image sensor cleaning** appears, and the dust you noticed has probably been shaken off.

You can also tell the D3000 when you'd like it to perform automatic cleaning without specific instructions from you. Chose **Clean at** and select from:

- **ON.** Clean at startup. This allows you to start a particular shooting session with a clean sensor.
- **OFF.** Clean at shutdown. This removes any dust that may have accumulated since the camera has been turned on, say, from dust infiltration while changing lenses. Note that this choice does not turn off automatic cleaning; it simply moves the operation to the camera power-down sequence.
- **ON/OFF.** Clean at both startup and shutdown. Use this setting if you're paranoid about dust and don't mind the extra battery power consumed each time the camera is turned on or off.
- **Cleaning Off.** No automatic dust removal will be performed. Use this to preserve battery power, or if you prefer to use automatic dust removal only when you explicitly want to apply it.

Mirror Lock-up

Options: Lock mirror up

You can also clean the sensor manually. Use this menu entry to raise the mirror and open the shutter so you'll have access to the sensor for cleaning with a blower, brush, or swab. You don't want power to fail while you're poking around inside the camera, so this option is available only when sufficient battery power (at least 60 percent) is available. Using a fully charged battery or connecting the D3000 to an EH-5/EH5a AC adapter is an even better idea.

Video Mode

Options: NTSC, PAL

This setting is the first option on the second "page" of the Setup menu (see Figure 4.4). It controls the output of the Nikon D3000 when directed to a conventional video system through the video cable when you're displaying images

Figure 4.4
The second page of the Setup menu has seven more entries.

on a monitor or connected to a VCR through the external device's yellow video input jack. You can select either **NTSC**, used in the United States, Canada, Mexico, many Central, South American, and Caribbean countries, much of Asia, and other countries; or **PAL**, which is used in the UK, much of Europe, Africa, India, China, and parts of the Middle East.

Time Zone and Date

Options: Time zone, Date, Date format, Daylight saving time

Use this menu entry to adjust the D3000's internal clock. Your options include:

- **Time zone.** A small map will pop up on the setting screen and you can choose your local time zone. I sometimes forget to change the time zone when I travel (especially when going to Europe), so my pictures are all time-stamped incorrectly. I like to use the time stamp to recall exactly when a photo was taken, so keeping this setting correct is important.

- **Date.** Use this setting to enter the exact year, month, day, hour, minute, and second.

- **Date format.** Choose from **Year/month/day** (Y/M/D), **Month/day/year** (M/D/Y), or **Day/month/year** (D/M/Y) formats.

- **Daylight saving time.** Use this to turn daylight saving time **On** or **Off**. Because the date on which DST takes effect has been changed from time to time, if you turn this feature on you may need to monitor your camera to make sure DST has been implemented correctly.

Language

Options: 15 languages

Choose from 15 languages for menu display, choosing from German, English, Spanish, Finnish, French, Italian, Dutch, Polish, Portuguese, Russian, Swedish, Traditional Chinese, Simplified Chinese, Japanese, or Korean.

Image Comment

Options: Input Comment, Attach Comment, Done

The **Image comment** is your opportunity to add a copyright notice, personal information about yourself (including contact info), or even a description of where the image was taken. The embedded comments can be read by many software programs, including Nikon ViewNX or Capture NX.

The standard text entry screen can be used to enter your comment, with up to 36 characters available. For the copyright symbol, embed a lowercase "c" within opening and closing parentheses: **(c)**. You can enter text by choosing **Input comment**, turn attachment of the comment On or Off using the **Attach comment** entry, and select **Done** when you're finished working with comments. If you find typing with a cursor too tedious, you can enter your comment in Nikon Capture NX and upload it to the camera through a USB cable.

Now is a good time to review text entry, because you can use it to enter comments, rename folders, and perform other functions.

1. Press MENU and select the Setup menu.
2. Scroll to **Image comment** with the multi selector up/down buttons and press the multi selector right button.
3. Scroll down to **Input comment** and press the multi selector right button to confirm your choice.
4. Use the multi selector navigational buttons to scroll around within the array of alphanumerics, as shown in Figure 4.5. There is a full array of uppercase, lowercase, and symbol characters. They can't be viewed all at once, so you may need to scroll up or down to locate the one you want. Then, enter your text:
 - Press the Zoom In button to insert the highlighted character. The cursor will move one place to the right to accept the next character.
 - Rotate the command dial buttons to move the cursor within the line of characters that have been input.
 - To remove a character you've already input, move the cursor with the command dial to highlight that character, and then press the Trash button.
 - When you're finished entering text, press the multi selector OK button to confirm your entry and return to the **Image comment** screen.

Figure 4.5
Enter a comment on this screen.

5. In the **Image comment** screen, scroll down to **Attach comment** and press the multi selector right button to activate the comment, or to disable it.

6. When finished, scroll up to **Done** and press OK.

Auto Image Rotation

Options: On, Off

Turning this setting on tells the Nikon D3000 to include camera orientation information in the image file. The orientation can be read by many software applications, including Adobe Photoshop, Nikon ViewNX, and Capture NX, as well as the **Rotate tall** setting in the Playback menu. Turn this feature off, and none of the software applications or Playback's **Rotate tall** will be able to determine the correct orientation for the image. Nikon notes that only the first image's orientation is used when shooting continuous bursts; subsequent photos will be assigned the same orientation, even if you rotate the camera during the sequence.

Dust Off Ref Photo

Options: Start, Clean sensor, then start

This menu choice lets you "take a picture" of any dust or other particles that may be adhering to your sensor. The D3000 will then append information about the location of this dust to your photos, so that the Image Dust Off option in Capture NX can be used to mask the dust in the NEF image.

To use this feature, select **Dust Off ref photo**, choose either **Start** or **Clean sensor, then start**, and then press OK. If directed to do so, the camera will first perform a self-cleaning operation by applying ultrasonic vibration to the low-pass filter that resides on top of the sensor. Then, a screen will appear asking you to take a photo of a bright featureless white object 10 cm from the lens. Nikon recommends using a lens with a focal length of at least 50mm. Point the D3000 at a solid white card and press the shutter release. An image with the extension .ndf will be created, and can be used by Nikon Capture NX as a reference photo if the "dust off" picture is placed in the same folder as an image to be processed for dust removal.

Auto Off Timers

Options: Short, Norm, Long, Custom: Playback/menus, Image review, Auto meter-off

Use this setting to determine how long the D3000's LCD and viewfinder displays, and exposure meters continue to operate after the last operation, such as autofocusing, focus point selection, and so forth, was performed. You can choose a short timer to save power, or a longer value to keep the camera "alive" for a longer period of time. When the Nikon EH5a/EH-5 AC adapter is connected to the D3000, the exposure meters will remain on indefinitely, and when the D3000 is connected to a computer or PictBridge-compatible printer, the LCD and viewfinder displays do not turn off automatically. Sports shooters and some others prefer longer delays, because they are able to keep their camera always "at the ready" with no delay to interfere with taking an action shot that unexpectedly presents itself.

- **Short.** LCD Playback/Menus: 8 seconds; LCD Review: 4 seconds; Exposure Meters: 4 seconds.
- **Norm.** LCD Playback/Menus: 12 seconds; LCD Review: 4 seconds; Exposure Meters: 8 seconds.
- **Long.** LCD Playback/Menus: 20 seconds; LCD Review: 20 seconds; Exposure Meters: 60 seconds.
- **Custom: Playback/menus.** Choose 8, 12, 20, 60 seconds, or 10 minutes.
- **Custom: Image review.** Choose 4, 8, 20, 60 seconds, or 10 minutes.
- **Custom: Auto meter-off.** Choose 4, 8, 20, 60 seconds, or 30 minutes.

Self-Timer Delay

Options: 2, 5, 10, 20 seconds

This setting, the first on the next page of the Setup menu (see Figure 4.6) lets you choose the length of the self-timer shutter release delay. The default value is 10 seconds. You can also choose 2, 5, or 20 seconds. If I have the camera mounted on a tripod or other support and am too lazy to reach for my ML-L3 infrared remote, I can set a 2-second delay that is sufficient to let the camera stop vibrating after I've pressed the shutter release. I use a longer delay time if I am racing to get into the picture myself and am not sure I can make it in 10 seconds.

Remote on Duration

Options: 1 min, 5 min (default), 10 min, 15 min

Use this simple option to specify how long the camera will remain active waiting for a signal from the ML-L3 infrared remote. You can specify 1 minute, 5 minutes (the default value), 10, or 15 minutes. Longer values are useful, say, when you've set the camera up on a tripod and are lying in wait for the elusive snipe to approach your snipe-feeder. It would be a good idea to have a fully charged battery when trying this, however.

Figure 4.6
Self-timer delay is the first entry on the next page of the Setup menu.

Beep

Options: On, Off

The Nikon D3000's internal beeper provides a (usually) superfluous chirp to signify various functions, such as the countdown of your camera's self-timer or autofocus confirmation in AF-S mode or AF-A mode with a static subject. You can (and probably should) switch it off if you want to avoid the beep because it's annoying, impolite, or distracting (at a concert or museum), or undesired for any other reason.

Viewfinder Options

Options: Viewfinder grid (On, Off), Rangefinder (On, Off)

Here, you can turn the viewfinder grid on or off, as well as the D3000's Rangefinder feature. The grid is an array of lines overlaid on the viewfinder, offering some help when you want to align vertical or horizontal lines. Note that the intersections of these lines do *not* follow the Rule of Thirds convention.

The Rangefinder is a clever feature, when activated, that supplements the green focus confirmation indicator at the left edge of the viewfinder by transforming the analog exposure indicator as an "in-focus/out-of-focus" scale to show that correct focus has been achieved when focusing manually.

Some lenses don't offer autofocus features with the Nikon D3000, because they lack the internal autofocus motor the D3000 requires. Many manual focus lenses that never had autofocus features can also be used with the D3000 in manual focus mode. All you need to know is that Nikon lenses with the AF-S designation in the lens name *will* autofocus on the D3000, while those with the AF, AI, or AI-S designation will not. Specifications for lenses from other vendors will indicate whether the lens includes an autofocus motor or not.

When a non-autofocus lens is mounted on the Nikon D3000, and the camera has been set for any exposure mode except for Manual (M)—that is, any of the Scene modes, plus Program, Aperture-Priority, or Shutter-priority—manual focus mode is automatically activated. You can manually focus by turning the focus ring on the lens (set the lens to Manual focus if it is an AF-type lens) and watching the sharpness of the image on the focusing screen. The focus confirmation indicator at the lower-left corner of the viewfinder will illuminate when correct focus is achieved, if your lens has a maximum aperture of f/5.6 or larger (such as f/5.6, f/4.5, f/4, and so forth).

Tip

Note that this feature is not available when shooting in Manual *exposure* mode however. The D3000 shows whether exposure is under, over, or correct, instead. Use the focus confirmation lamp to monitor manual focus in this mode.

The readout in the viewfinder is not analog (that is, continuous). Only the six indicators shown in Figure 4.7 are displayed. Two centered rectangles indicate that correct focus has been achieved; when all 12 are shown, it means that correct focus cannot be indicated. Three and six rectangles show that slight or major focus corrections are needed, respectively.

Turn the Rangefinder on if you want an additional manual focusing aid. With a manual focus lens and the Rangefinder operating, the analog exposure display at bottom right in the viewfinder will be replaced by a rangefinder focusing scale. Indicators on the scale like those in Figure 4.7 show when the image is in sharp focus, as well as when you have focused somewhat in front of, or behind the subject. Follow these steps to use the Rangefinder:

1. Press the multi selector buttons to choose a focus point that coincides with the subject you'd like to be in focus.

Figure 4.7 Upper left: correct focus; upper right: focus is grossly incorrect; center left: focus slightly in front of the subject; center right: focus slightly behind the subject; bottom left: focus significantly in front of the subject; bottom right: focus significantly behind the subject.

2. Rotate the focusing ring, watching the rangefinder scale at the bottom of the viewfinder. If the current sharp focus plane is *in front* of the point of desired focus, the rangefinder scale will point towards the left side of the viewfinder. The greater the difference, the more bars (either three or six bars) shown in the rangefinder.

3. When the current focus plane is *behind* the desired point of focus, the rangefinder indicator will point to the right.

4. When the subject you've selected with the focus zone bracket is in sharp focus, only two bars will appear, centered under the 0, and the focus confirmation indicator will stop blinking.

File Number Sequence

Options: On, Off

The Nikon D3000 will automatically apply a file number to each picture you take, using consecutive numbering for all your photos over a long period of time, spanning many different memory cards, starting over from scratch when you insert a new card, or when you manually reset the numbers. Numbers are applied from 0001 to 9999, at which time the D3000 "rolls over" to 0001 again.

The camera keeps track of the last number used in its internal memory and, if **File number sequence** is turned **On**, will apply a number that's one higher, or a number that's one higher than the largest number in the current folder on the memory card inserted in the camera. You can also start over each time a new folder has been created on the memory card, or reset the current counter back to 0001 at any time. When **Off**, the numbers are started from 0001 each time.

Buttons

Options: Define Self-timer/Fn button, AE-L/AF-L button, AE lock button

You can define the action that the Self-timer/Fn button, AE-L/AF-L, and AE lock buttons perform when pressed alone. Each of the buttons has its own set of actions that you can define for them.

Self-Timer/Fn Button

There are seven different actions you can define for the Self-timer/Fn button:

■ **Self-timer.** This is the default setting and the one I recommend keeping, unless you never use the Self-timer. When the button is pressed, the Nikon D3000 shifts into Self-timer mode, and the next time you press the shutter release button all the way, the Self-timer will activate.

■ **Release mode.** When this option is selected, pressing the Fn button pops up a modified version of the information edit screen on the LCD, with the Release mode function active. (You can set the mode directly from this information edit screen; it's not necessary to venture into the submenu.) Just rotate the command dial until the release mode you want appears on the LCD. This is an acceptable alternative to the default value if you use the Self-timer sometimes, but want to use one of the other release modes from time to time.

■ **Image Size/Qual.** With this setting, when the Fn button is pressed, the information edit screen pops up, and you can rotate the command dial to view and select image quality (RAW, JPEG Fine, JPEG Norm, JPEG Basic, or RAW+Basic) and image size (for JPEG images). When specifying JPEG quality and size, the information edit display cycles among the three quality settings, then moves to the next lower size, allowing you to set both with one (extended) rotation of the command dial. For example, the Fine, Normal, and Basic Large settings are shown first, followed by Fine, Normal, Basic Medium, and Fine, Normal Basic Small. I never use this function key definition; it's easier just to use the information edit menu, and I rarely change image size, anyway.

■ **ISO sensitivity.** Use this option if you want to adjust the ISO setting using the Fn key. The information edit screen appears, and you can rotate the command dial to choose an ISO sensitivity.

■ **White balance.** When the Fn button is pressed, you can rotate the command dial to select one of the white balance settings when using Program, Shutter-priority, Aperture-priority, or Manual exposure modes.

■ **Active D-Lighting.** This allows you to choose the Active D-Lighting mode using the Fn button and rotating the command dial.

■ **Set framing grid.** Press the Fn button and rotate the command dial to turn the framing grid on or off.

AE-L/AF-L button

When the Nikon D3000 is set to its default values, a half-press of the shutter release locks in the current autofocus setting in AF-S mode, or in AF-A mode if your subject is not moving. (The camera will refocus if the subject moves and the D3000 is set for AF-C or AF-A mode.) That half-press also activates the exposure meter, but, ordinarily, the exposure changes as the lighting conditions in the frame change.

However, sometimes you want to lock in focus and/or exposure, and then reframe your photo. For that, and for other focus/exposure locking options, Nikon gives you the AE-L/AF-L button (located on the back of the camera to

the right of the viewfinder window), and a variety of behavior combinations for it. This CSM (Custom Setting Menu) setting allows you to define whether the Nikon D3000 locks exposure, focus, or both when the button is pressed, so the AE-L/AF-L button can be used for these functions in addition to, or instead of a half-press of the shutter release. It can also be set so that autofocus starts *only* when the button is pressed; in that case, a half-press of the shutter release initiates autoexposure, but the AE-L/AF-L button *must* be pressed to start the auto-focusing process. These options can be a little confusing, so I'll offer some clarification:

- **AE/AF lock.** Lock both focus and exposure while the AE-L/AF-L button is pressed and held down, even if the shutter release button has not been pressed. This is the default value, and is useful when you want to activate and lock in exposure and focus independently of the shutter release button. Perhaps your main subject is off-center; place that subject in the middle of the frame, lock in exposure and focus, and then reframe the picture while holding the AE-L/AF-L button.

- **AE lock only.** Lock only the exposure while the AE-L/AF-L button is pressed. The exposure is fixed when you press and hold the button, but aut-ofocus continues to operate (say, when you press the shutter release halfway) using the AF-A, AF-S, or AF-C mode you've chosen.

- **AF lock only.** Focus is locked in while the AE-L/AF-L button is held down, but exposure will continue to vary as you compose the photo and press the shutter release button.

- **AE lock (Hold).** Exposure is locked when the AE-L/AF-L button is pressed, and remains locked until the button is pressed again, or the exposure meter-off delay expires. Use this option when you want to lock exposure at some point, but don't want to keep your thumb on the AE-L/AF-L button.

- **AF (AF-ON).** The AE-L/AF-L button is used to initiate autofocus. A half-press of the shutter release button does not activate or change focus. This setting is useful when you want to frame your photo, press the shutter release halfway to lock in exposure, but don't want the D3000 to autofocus until you tell it to. I use this for sports photography when I am waiting for some action to move into the frame before starting autofocus. For example, I might press the AE-L/AF-L button just before a racehorse crosses the fin-ish line.

AE Lock

When you turn this option **On**, the exposure locks when the shutter release but-ton is pressed halfway. When **Off** (the default), a shutter release half-press does not lock exposure; the camera will continue to adjust exposure until you press

the shutter release all the way to take the picture, or take your finger off the button. Set this option to **Off** when you are shooting under lighting conditions that may change suddenly; use **On** when you want the exposure to remain constant even if the lighting changes. You might do this while recording a series of scenes illuminated by the setting sun, and wanted the scene to gradually get darker as the sun sinks behind the horizon. With the default **Off** setting, the D3000 would constantly compensate for the waning light, rendering each shot similar in appearance.

No Memory Card?

Options: Enable release, Release locked

This entry gives you the ability to snap off "pictures" without a memory card installed—or, alternatively, to lock the camera shutter release if no card is present. Choose **Enable release** to activate "play" mode or **Release locked** to disable it. The pictures you actually "take" are displayed on the LCD with the legend "Demo" superimposed on the screen, and they are, of course, not saved. Note that if you are using the optional Camera Control Pro 2 software to record photos from a USB-tethered D3000 directly to a computer, no memory card is required to unlock the shutter even if **Release locked** has been selected.

Date Imprint

Options: Off, Date, Date/time, Date counter

This is the first entry of the last batch you'll see in the Setup menu as you scroll down. (See Figure 4.8.) You can superimpose the date, time, or both on your

Figure 4.8
Scrolling down reveals the last few entries in the Setup menu.

photographs, or imprint a date counter that shows the number of days (or years and days, or months, years, and days) between when the picture was taken and a date (in the past or future) that you select. The good news is that this feature can be useful for certain types of photographs used for documentation. While the D3000's time/date stamp may not be admissible in a court of law, it makes a convincing (or convenient) in-picture indication of when the shot was made. This feature works only with JPEG images; you cannot use **Date imprint** with pictures taken using the RAW or RAW+Basic settings.

The bad news, especially if you use the feature accidentally, is that the imprint is a permanent part of the photograph. You'll have to polish up your Photoshop skills if you want to remove it, or, at the very least, crop it out of the picture area. Date and time are set using the format you specify in the **World time** setting of the Setup menu, described in the next section.

Your options, as seen in Figure 4.9, are

- **Off.** Deactivates the date/time imprint feature.
- **Date.** The date is overlaid on your image in the bottom-right corner of the frame, and appears in the shooting information display. If you've turned on **Auto image rotation** the date is overlaid at the bottom-right corner of vertically oriented frames.
- **Date/Time.** Both date and time are imprinted, in the same positions.
- **Date Counter.** This option imprints the current date on the image, but also adds the number of days that have elapsed since a particular date in the past that you specify, *or* the days remaining until an upcoming date in the future.

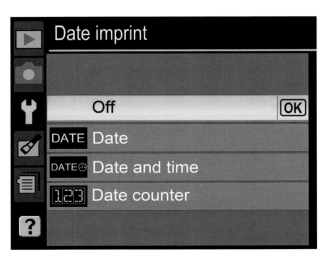

Figure 4.9
Choose date, date and time, or date counter.

Using the Date Counter

If you're willing to have information indelibly embedded in your images, the **Date counter** can be a versatile feature. You can specify several parameters in advance (or at the time you apply the **Date counter**) and activate the overprinting *only* when you want it. The parameters, shown in Figure 4.10, are as follows:

- **Off.** Select this from the main **Date imprint** screen. Choosing **Off** disables the imprinting of date, date/time, *and* the **Date counter**. When disabled, no date or counter information is shown, regardless of how you have set the other parameters.

- **Choose date.** When you enter the **Date counter** screen, one option lets you enter up to three different dates for your countdown/countup. When you activate the **Date counter**, you can choose from the three dates (or a new date you enter to replace one of the three) and use that for your date counting imprint.

- **Display options.** Also in the **Date counter** screen, you can select **Display options**, which allows you to specify **Number of days**, **Years and days**, or **Years, months, and days** for the **Date counter** readout imprinted on your images.

- **Done.** When you've finished entering date and display options, choose **Done** to return to the Custom Setting menu. (You *must* do this. If you press the MENU button or tap the shutter release button at this point, your changes will not be confirmed.)

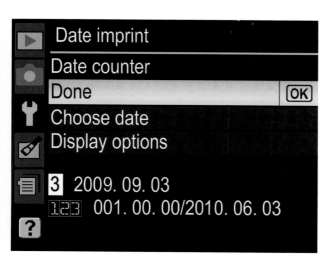

Figure 4.10
Select a date in the past or future.

Active Folder

Options: Select folder, Delete, Rename

If you want to store images in a folder other than the one created and selected by the Nikon D3000, you can switch among available folders on your memory card, or create your own folder. Remember that any folders you create will be deleted when you reformat your memory card.

The Nikon D3000 automatically creates a folder on a newly formatted memory card with a name like 100NCD3000, and when it fills with 999 images, will automatically create a new folder with a number incremented by one (such as 101NCD3000). The numeric portion of the folder name is always created by the D3000; your folder choice is based on the remaining five characters.

To change the currently active folder:

1. Choose **Folders** in the Setup menu.
2. Scroll down to **Select folder** and press the multi selector right button.
3. From among the available folders shown, scroll to the one that you want to become active for image storage and playback. (Handy when displaying slide shows.)
4. Press the OK button to confirm your choice, or press the multi selector right button to return to the Setup menu.
5. You can also choose **Delete** within the Folders menu to remove all empty folders on your memory card. This option is useful when you've created a bunch of folders and decided not to use them.

To create your own folder, or to rename an existing folder:

1. Choose **Folders** in the Setup menu.
2. Scroll down to **New** and press the multi selector right button. You can also select **Rename** to apply a new name to an existing folder; you'll be asked to choose a folder before proceeding.
3. Use the text-entry screen shown earlier to enter a name for your folder. Follow the instructions I outlined under "Image Comment" to enter text. The **Folder** text screen has only uppercase characters and the numbers 0-9, and just five letters can be entered.
4. Press the Zoom button when finished to create and activate the new or renamed folder and return to the Setup menu.

Eye-Fi Upload

Options: Enable, Disable

This option (not shown in the figure) is displayed only when a compatible Eye-Fi memory card is being used in the D3000. The Eye-Fi card looks like an ordinary SDHC memory card, but has built-in WiFi capabilities, so it can be used to transmit your photos as they are taken directly to a computer over a WiFi network.

Firmware Version

Options: None

You can see the current firmware release in use in this menu listing; you must scroll to view the menu entry that provides the information.

Retouch Menu

The Retouch menu has seven entries on its first screen (see Figure 4.11). This menu allows you to create a new copy of an existing image with trimmed or retouched characteristics. You can apply D-Lighting, remove red-eye, create a monochrome image, apply filter effects, rebalance color, overlay one image on another, and compare two images side-by-side. Just select a picture during Playback mode, and then scroll down to one of the retouching options. You can also go directly to the Retouch menu, select a retouching feature, and then choose a picture from the standard D3000 picture selection screen.

Figure 4.11
The Retouch menu allows simple in-camera editing.

The Retouch menu is most useful when you want to create a modified copy of an image on the spot, for immediate printing or e-mailing without first importing into your computer for more extensive editing. You can also use it to create a JPEG version of an image in the camera when you are shooting RAW-only photos.

You can retouch images that have already been processed by the Retouch menu. You can apply up to 10 different effects, in total, but only once per effect (except for **Image overlay**). You may notice some quality loss with repeated applications.

To create a retouched copy of an image:

1. While browsing among images in Playback mode, press OK when an image you want to retouch is displayed on the screen. The Retouch menu will pop up, and you can select a retouching option.

2. From the Retouch menu, select the option you want and press the multi selector right button. The Nikon D3000's standard image selection screen appears. Scroll among the images as usual with the left/right multi selector buttons, press the Zoom button to examine a highlighted image more closely, and press OK to choose that image.

3. Work with the options available from that particular Retouch menu feature and press OK to create the modified copy, or Playback to cancel your changes.

4. The retouched image will bear a filename that reveals its origin. For example, if you make a **Small picture** version of an image named DSC_0112.jpg, the reduced-size copy will be named SSC_0113.jpg. Copies incorporating other retouching features would be named CSC_0113.jpg instead.

- D-Lighting
- Red-eye correction
- Trim
- Monochrome
- Filter effects
- Color balance
- Small picture
- Image overlay
- NEF (Raw processing)
- Quick retouch
- Color outline
- Miniature effect
- Stop-motion movie
- Before and after

D-Lighting

This option brightens the shadows of pictures that have already been taken. It is a useful tool for backlit photographs or any image with deep shadows with important detail. Once you've selected your photo for modification, you'll be shown side-by-side images with the unaltered version on the left, and your

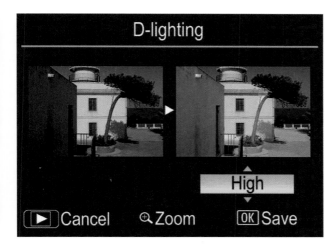

Figure 4.12
Use the D-Lighting feature to brighten dark shadows.

adjusted version on the right. Press the multi selector's up/down buttons to choose from High, Normal, or Low corrections. Press the Zoom In button to magnify the image. When you're happy with the corrected image on the right, compared to the original on the left, press OK to save the copy to your memory card. (See Figure 4.12.)

Red-Eye Correction

This Retouch menu tool can be used to remove the residual red-eye look that remains after applying the Nikon D3000's other remedies, such as the red-eye reduction lamp. (You can use the red-eye tools found in most image editors, as well.)

The best way to truly eliminate red-eye is to raise the flash up off the camera so its illumination approaches the eye from an angle that won't reflect directly back to the retina and into the lens. The extra height of the built-in flash may not be sufficient, however. If you're working with your D3000's built-in flash, your only recourse may be to switch on the red-eye reduction flash mode. That causes a lamp on the front of the camera to illuminate with a half-press of the shutter release button, which may result in your subjects' pupils contracting, decreasing the amount of the red-eye effect. (You may have to ask your subject to look at the lamp to gain maximum effect.)

If your image still displays red-eye effects, you can use the Retouch menu to make a copy with red-eye reduced further. First, select a picture that was taken with flash (non-flash pictures won't be available for selection). After you've selected

the picture to process, press OK. The image will be displayed on the LCD. You can magnify the image with the Zoom In button, scroll around the zoomed image with the multi selector buttons, and zoom out with the Zoom Out button. While zoomed, you can cancel the zoom by pressing the OK button.

When you are finished examining the image, press OK again. The D3000 will look for red-eye, and, if detected, create a copy that has been processed to reduce the effect. If no red-eye is found, a copy is not created.

Trim

This option creates copies in specific sizes based on the final size you select, chosen from among 3:2, 4:3, and 5:4 aspect rations (proportions). You can use this feature to create smaller versions of a picture for e-mailing without the need to first transfer the image to your own computer. Just follow these steps:

1. **Select your photo.** Choose **Trim** from the Retouch menu. You'll be shown the standard Nikon D3000 **Image selection** screen. Scroll among the photos using the multi selector left/right buttons, and press OK when the image you want to trim is highlighted. While selecting, you can temporarily enlarge the highlighted image by pressing the Zoom button.

2. **Choose your aspect ratio.** Rotate the command dial to change from 3:2, 4:3, and 5:4 aspect ratios. These proportions happen to correspond to the proportions of common print sizes, including the two most popular sizes: 4 × 6-inches (3:2) and 8 × 10-inches (5:4).

3. **Crop in on your photo.** Press the Zoom button to crop in on your picture. The pixel dimensions of the cropped image at the selected proportions will be displayed in the upper-left corner (see Figure 4.13) as you zoom. The current framed size is outlined in yellow within an inset image in the lower-right corner.

Table 4.2 Trim Sizes	
Aspect Ratio	**Sizes Available**
3:2	3424 × 2280, 2560 × 1704, 1920 × 1280, 1280 × 856, 960 × 640, 640 × 424
4:3	3424 × 2568, 2560 × 1920, 1920 × 1440, 1280 × 960, 960 × 720, 640 × 480
5:4	3216 × 2568, 2400 × 1920, 1808 × 1440, 1200 × 960, 986 × 720, 608 × 480

Figure 4.13
The Trim feature of the Retouch menu allows in-camera cropping.

4. **Move cropped area within the image.** Use the multi selector left/right and up/down buttons to relocate the yellow cropping border within the frame.

5. **Save the cropped image.** Press OK to save a copy of the image using the current crop and size, or press the Playback button to exit without creating a copy. Copies created from JPEG Fine, Normal, or Standard have the same **Image quality** setting as the original; copies made from RAW files or any RAW+JPEG setting will use JPEG Fine compression. When reviewing saved photos, small pictures are indicated by a gray border.

Monochrome

This Retouch choice allows you to produce a copy of the selected photo as a black-and-white image, sepia-toned image, or cyanotype (blue-and-white). You can fine-tune the color saturation of the previewed Sepia or Cyanotype version by pressing the multi selector up button to increase color richness, and the down button to decrease saturation. When satisfied, press OK to create the monochrome duplicate.

Filter Effects

Add effects somewhat similar to photographic filters with this tool. You can choose from among six different choices:

- **Skylight.** This option makes the image slightly less blue.
- **Warm.** Use this filter to add a rich warm cast to the duplicate.

- **Red, Green, Blue intensifiers.** These three options make the red, green, and blue hues brighter, respectively. Use them to brighten a rose, intensify the greens of foliage, or deepen the blue of the sky.
- **Cross screen.** This option adds radiating star points to bright objects—such as the reflection of light sources on shiny surfaces. You can choose four different attributes of your stars:

 Number of points. You can select from four, six, or eight points for each star in your image.

 Filter amount. Select from three different intensities, represented by two, three, and four stars in the menu (this doesn't reflect the actual number of stars in your image, which is determined by the number of bright areas in the photo).

 Filter angle. Select from three different angles: steep, approximately 45 degrees, and a shallower angle.

 Length of points. Three different lengths for the points can be chosen: short, medium, and long.
- **Soft.** Creates a dreamy, soft-focus version of your image. You can compare the "before" and "after" versions using a screen much like the one used for D-Lighting.

After adjusting filter effects, press OK to make a copy of the photo with the effect added.

Color Balance

This option produces the screen shown in Figure 4.14, with a preview image of your photo. Use the multi selector up/down (green/pink) and left/right buttons (blue/red) to bias the color of your image in the direction of the hues shown on the color square below the preview.

Small Picture

This option, the first in the second page of the Retouch menu (see Figure 4.15), allows you to create small copies of full images (without cropping or trimming) at resolutions of 640×480, 320×240, or 160×120. All three of these optional small sizes may be useful for e-mailing, website display, or use in presentations on television screens.

To create a **Small picture** copy:

1. Choose **Small picture** from the Retouch menu.
2. Select **Choose size** and specify your preference from among the three available sizes, **640×480**, **320×240**, or **160×120**. Press OK.

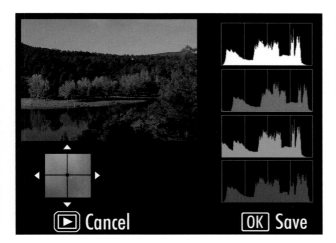

Figure 4.14
Press the multi selector buttons to bias the color in the direction you prefer.

Figure 4.15
Small picture is the first choice in the second page of the Retouch menu.

3. Next, choose **Select picture** and choose your image using the standard Nikon D3000 image selection screen.

4. Press the up/down button to mark a highlighted image for reduction.

5. You can select more than one picture, marking each with the up/down button. Use the button to unmark any photos if you change your mind.

6. Press OK. You'll see a message: **Create small picture? 2 images**. (Or whatever number of images you have marked.)

7. Press OK to create the small pictures.

Image Overlay

The **Image overlay** tool allows you to combine two RAW photos (only NEF files can be used) in a composite image that Nikon claims is better than a "double exposure" created in an image-editing application because the overlays are made using RAW data. To produce this composite image, follow these steps:

1. Choose **Image overlay**. The screen shown in Figure 4.16 will be displayed, with the Image 1 box highlighted.

2. Press OK and the Nikon D3000's image selection screen appears. Choose the first image for the overlay and press OK.

3. Press the multi selector right button to highlight the Image 2 box, and press OK to produce the image selection screen. Choose the second image for the overlay.

4. By highlighting either the Image 1 or Image 2 boxes and pressing the multi selector up/down buttons, you can adjust the "gain," or how much of the final image will be "exposed" from the selected picture. You can choose from X0.5 (half-exposure) to X2.0 (twice the exposure) for each image. The default value is 1.0 for each, so that each image will contribute equally to the final exposure.

5. Use the multi selector right button to highlight the Preview box and view the combined picture. Press the Zoom button to enlarge the view.

6. When you're ready to store your composite copy, press the multi selector down button when the Preview box is highlighted to select **Save**, and press OK. The combined image is stored on the memory card.

Figure 4.16
Overlay two RAW images to produce a "double exposure."

NEF (RAW) Processing

Use this tool to create a JPEG version of any image saved in either straight RAW (with no JPEG version) or RAW+Basic (with a Basic JPEG version). You can select from among several parameters to "process" your new JPEG copy right in the camera.

1. Choose a RAW image. Select **NEF (RAW) processing** from the Retouch menu. You'll be shown the standard Nikon D3000 image selection screen. Use the left/right buttons to navigate among the RAW images displayed. Press OK to select the highlighted image.

2. In the NEF (RAW) processing screen you can use the multi selector up/down keys to select from five different attributes of the RAW image information to apply to your JPEG copy. Choose **Image quality** (Fine, Normal, or Basic), **Image size** (Large, Medium, or Small), **White balance**, **Exposure compensation**, and **Set Picture Control** parameters.

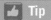 **Tip**

The White balance parameter cannot be selected for images created with the Image overlay tool, and the Preset manual white balance setting can be fine-tuned only with images that were originally shot using the Preset white balance setting. Exposure compensation cannot be adjusted for images taken using Active D-Lighting, and both white balance and optimize image settings cannot be applied to pictures taken using any of the Scene modes.

3. Press the Zoom button to magnify the image temporarily while the button is held down.

4. Press the Playback button if you change your mind, to exit from the processing screen.

5. When all parameters are set, highlight **EXE** (for Execute) and press OK. The D3000 will create a JPEG file with the settings you've specified, and show an **Image saved** message on the LCD when finished.

Quick Retouch

This option brightens the shadows of pictures that have already been taken. Once you've selected your photo for processing, use the multi selector up/down keys in the screen that pops up. The amount of correction that you select (**High**, **Normal**, or **Low**) will be applied to the version of the image shown at right. The

left-hand version of the image shows the uncorrected version. While working on your image, you can press the Zoom image to temporarily magnify the original photo. **Quick retouch** brightens shadows, enhances contrast, and adds color richness (saturation) to the image. Press OK to create a copy on your memory card with the retouching applied.

Color Outline

This option creates a copy of your image in outline form, which Nikon says you can use for "painting." You might like the effect on its own. It's a little like the Find Edges command in Photoshop and Photoshop Elements, but you can perform this magic in your camera!

Miniature Effect

This is a new effect introduced with the Nikon D3000, and it's hampered by a misleading name and the fact that its properties are hard to visualize (which is not a great attribute for a visual effect). This tool doesn't create a "miniature" picture, as you might expect. What it does is mimic tilt/shift lens effects that angle the lens off the axis of the sensor plane to drastically change the plane of focus, producing the sort of look you get when viewing some photographs of a diorama, or miniature scene. Confused yet?

Perhaps the best way to understand this capability is to actually modify a picture using it. Just follow these steps:

1. **Take your best shot.** Capture an image of a distant landscape or other scene, preferably from a slightly elevated viewpoint.
2. **Access Miniature effect.** When viewing the image during playback, press the multi selector center button to access the Retouch menu, and select **Miniature effect**. A screen like the one shown at left in Figure 4.17 appears.

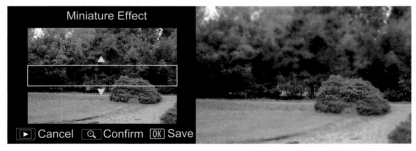

Figure 4.17 Choose the area for sharp focus by moving the yellow box within the frame.

3. **Adjust selected area.** A wide yellow box (or a tall yellow box if the image is rotated to vertical perspective on playback) highlights a small section of the image. (No, we're not going to create a panorama from that slice; this Nikon super-tricky feature has fooled you yet again.) Use the up/down buttons (or left/right buttons if the image is displayed vertically) to move the yellow box, which represents the area of your image that will be rendered in (fairly) sharp focus. The rest of the image will be blurred.

4. **Preview area to be in sharp focus.** Press the Zoom button to preview the area that will be rendered in sharp focus. Nikon labels this control **Confirm**, but that's just to mislead you. It's actually just a preview that lets you "confirm" that this is the area you want to emphasize.

5. **Apply the effect.** Press the OK button to apply the effect (or the Playback button to cancel). Your finished image will be rendered in a weird altered-focus way, as shown at right in Figure 4.17.

Stop-Motion Movie

Analyze your golf swing, make flip-book movies, or create animations for your web page using this clever capability. This is one tool readily available in your Nikon D3000 that ordinarily requires an image editor or standalone program in your computer. The movies aren't sophisticated, but they are surprisingly effective.

Your first step is to create a series of frames that can be assembled into a stop-motion movie. You can shoot a series of pictures at 3 fps using your D3000's Continuous shooting mode, if you like. Or, you can take the pictures one at a time. If you were doing clay animation, for example, you'd mount your camera firmly on a tripod, take the first picture in a series, then move your clay figures slightly, take the next picture, and repeat multiple times (a hundred times if you're ambitious!). The Nikon ML-L3 infrared remote control, and the D3000 set to Quick release mode would help you not move the camera between exposures. I'd recommend using a non-variable light source (such as lamps indoors) and setting the D3000 for manual exposure to ensure that the exposure of each frame is identical.

Then, when you've collected all your shots on a single memory card, it's time to create the stop-motion movie. When you choose this option from the Retouch menu, a screen with three choices appears. Highlight any of the three and press OK:

■ **Create movie.** This choice leads you to a submenu where you select the actual frames that will be used to make your movie.

■ **Frame size.** Here, you choose frame sizes from **640 × 480** (good for full-screen movies on your computer display or a television); **320 × 240** (for smaller, more compact movies); and **160 × 120** (which produces coarse movies that are not much larger than a postage stamp on most computer screens, but which are better suited for display over the Internet, because their file size is very small).

■ **Frame rate.** The frame rate determines how many pictures are displayed each second. The standard for video display is 30 frames per second. The fastest frame rate available for these stop-motion movies is 15 frames per second, which produces a movie that displays a little jerkiness. You can also choose 10 fps, 6 fps, and 3 fps rates, which produce a little less smoothness, but allow for longer movies with a given number of frames to work with.

The **Create movie** screen is the editing and assembly portion of the stop-motion movie tool. You'll see a screen like the one shown in Figure 4.18.

1. All the images available for the movie will be shown in a continuous strip in the top half of the screen. Press the multi selector left/right buttons to move along the strip until you have highlighted the first image in the movie sequence. Press OK to select it.

2. Press the multi selector left/right buttons to locate the last image in the sequence, and press OK to select it. You can include 100 images, in total, between the first and last in the sequence. All selected images will be marked with a checkmark.

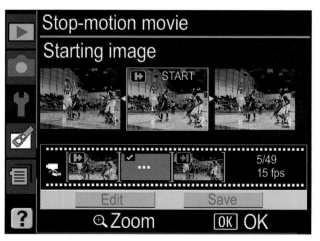

Figure 4.18
Choose first and last frames of your stop-motion movie here; then either Edit or Save the clip.

3. If you like, you can select **Edit** to change the **Start, Middle,** or **End** image in your sequence. Modify the **Start** and **End** images to change the length of the sequence. Use the **Middle** editing feature to remove (unmark) images.

4. When satisfied, press **Save**.

5. A screen will appear with options to **Save, Preview,** change the **Frame rate,** or **Edit** the movie. It's usually a good idea to preview your movie (it will take a few seconds to create the preview), and then make any additional editing changes.

6. When you're happy with your movie after the preview, choose **Save**.

Before and After

Use this option to compare a retouched photo side-by-side with the original from which it was derived. Don't look for the **Before and after** entry in the Retouch menu. It doesn't appear there. Instead, this option is shown on the pop-up menu that appears when you are viewing an image (or copy) full screen and press the OK button.

To use **Before and after** comparisons:

1. Press the Playback button and review images in full-frame mode until you encounter a source image or retouched copy you want to compare. The retouched copy will have the retouching icon displayed in the upper-left corner. Press OK.

2. The Retouch menu with **Trim, Monochrome, Filter effects, Small picture,** and **Before and after** appears. These are the only options that can be applied to an image that has already been retouched. Scroll down to **Before and after** and press OK.

3. The original and retouched image will appear next to each other, with the retouching options you've used shown as a label above the images.

4. Highlight the original or the copy with the multi selector left/right buttons, and press the Zoom button to magnify the image to examine it more closely.

5. If you have created more than one copy of an original image, select the retouched version shown, and press the multi selector up/down buttons to view the other retouched copies. The up/down buttons will also let you view the other image used to create an **Image overlay** copy.

6. When done comparing, press the Playback button to exit.

Using Recent Settings

The last menu in the D3000's main menu screen is Recent Settings (see Figure 4.19), which simply shows an ever-changing roster of the 20 menu items you used most recently. Press the up/down buttons to highlight an entry, and the right button to select it. To remove an entry from the Recent Settings listing, highlight it and press the Trash button.

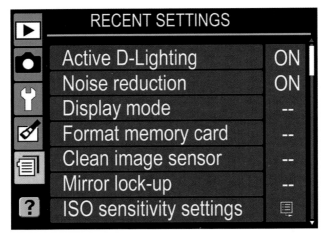

Figure 4.19
You can include your favorite menu items in the fast-access Recent Settings menu.

Chapter 5

Using the Flash

Your D3000 has a flip-up electronic flash unit built in, but you can also use an external flash (or, "strobe" or "Speedlight"), either mounted on the D3000's accessory shoe or used off-camera and linked with a cable or triggered by a slave light (which sets off a flash when it senses the firing of another unit). Consider using electronic flash:

- **When you need extra light.** Flash provides extra illumination in dark environments where existing light isn't enough for a good exposure, or is too uneven to allow a good exposure even with the camera mounted on a tripod.

- **When you don't need a precise preview of lighting effects.** Unless you're using a studio flash with a full-time modeling lamp, electronic flash works best when you are able to visualize its effects in your mind, or don't need a precise preview.

- **When you need to stop action.** The brief duration of electronic flash serves as a very high "shutter speed" when the flash is the main or only source of illumination for the photo. Your D3000's shutter speed may be set for 1/200th second during a flash exposure, but if the flash illumination predominates, the *effective* exposure time will be the 1/1,000th to 1/50,000th second or less duration of the flash, because the flash unit reduces the amount of light released by cutting short the duration of the flash. However, if the ambient light is strong enough, it may produce a secondary, "ghost" exposure, as I'll explain later in this chapter.

- **When you need flexibility.** Electronic flash's action-freezing power allows you to work without a tripod in the studio (and elsewhere), adding flexibility and speed when choosing angles and positions. Flash units can be easily filtered, and, because the filtration is placed over the light source rather than the lens, you don't need to use high quality filter material.

■ **When you can use—or counter—flash's relatively shallow "depth-of-light" (the inverse square law).** Electronic flash units don't have the sun's advantage of being located 93 million miles from the subject, and suffer from the effects of their proximity. The *inverse square law* dictates that as a light source's distance increases from the subject, the amount of light reaching the subject falls off proportionately to the square of the distance. In plain English, that means that a flash or lamp that's eight feet away from a subject provides only one-quarter as much illumination as a source that's four feet away (rather than half as much). (See Figure 5.1.) You can *use* this effect to separate subjects located at different distances thanks to the differing amount of illumination each receives. But when you want a larger area blanketed more evenly with illumination, you have to *counter* the effects of the inverse square law with supplemental lighting, slow shutter speeds (which allow ambient light to register along with the flash), bouncing the light off a ceiling or other surface to spread the light over a wider area, or by repositioning your subjects so all are within your flash's depth-of-light coverage.

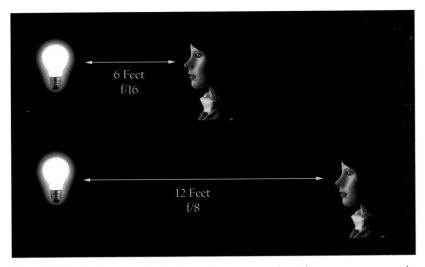

Figure 5.1 A light source that is twice as far away provides only one-quarter as much illumination.

Flash Control

The Nikon D3000's built-in flash has two modes, TTL (in two variations) and Manual. It does not have a repeating flash option, nor can it be used to trigger other Nikon flashes in Commander mode, unlike some more upscale cameras in the Nikon line. You can choose between TTL and Manual modes using the **Built-in flash** entry in the Shooting menu, described in Chapter 3. Note that the label on this menu listing changes to **Optional flash** when an SB-400 external flash is mounted on the D3000 and powered up. You can then make the same flash mode changes for the SB-400 as you can for the built-in flash. Other Nikon external flash units, such as the Nikon SB-900, have additional exposure modes available from menus on the flash itself. Your Flash control options are as follows:

- **TTL.** When the built-in flash is triggered, the D3000 first fires a pre-flash and measures the light reflected back and through the lens to calculate the proper exposure when the full flash is emitted a fraction of a second later. Either i-TTL Balanced Fill-flash or Standard i-TTL Fill-flash exposure calculation modes are used.

- **Manual.** You can set the level of the built-in flash from full power to 1/32 power. A flash icon blinks in the viewfinder and on the shooting information display when you're using Manual mode, and the built-in flash has been flipped up.

Flash Metering Mode

You don't select the way your flash meters the exposure directly; the two modes, i-TTL Balanced Fill-flash and Standard i-TTL Fill-flash, are determined by the camera metering mode—Matrix, Center-weighted, or Spot—that you select. Indeed, the built-in flash in the Nikon D3000, as well as external flash units attached to the camera, use the same three metering modes that are available for continuous light sources: Matrix, Center-weighted, and Spot. So, you can choose the flash's metering mode based on the same subject factors as those explained in Chapter 4 (for example, use Spot metering to measure exposure from an isolated subject within the frame). Choice of a metering mode determines how the flash reacts to balance the existing light with the light from the electronic unit:

- **i-TTL Balanced Fill-flash.** This flash mode is used automatically when you choose Matrix or Center-weighted exposure metering. The Nikon D3000 measures the available light and then adjusts the flash output to produce a natural balance between main subject and background. This setting is useful for most photographic situations.

■ **Standard i-TTL Fill-flash.** This mode is activated when you use Spot metering or choose the standard mode with an external flash unit's controls. The flash output is adjusted only for the main subject of your photograph, and the brightness of the background is not factored in. Use this mode when you want to emphasize the main subject at the expense of proper exposure for the background.

Choosing a Flash Sync Mode

The Nikon D3000 has five flash sync modes that determine when and how the flash is fired. They are selected from the information edit screen, or by holding down the flash button on the front of the camera lens housing while rotating the command dial. In both cases, the mode chosen appears in the information edit screen as the selection is made.

Not all sync modes are available with all exposure modes. Depending on whether you're using Scene modes, or Program, Shutter-priority, Aperture-priority, or Manual exposure modes, one or more of the following sync modes may not be available. I'm going to list the sync options available for each exposure mode separately, although that produces a little duplication among the options that are available with several exposure modes. However, this approach should reduce the confusion over which sync method is available with which exposure mode.

In Program and Aperture-priority modes, you can select these flash modes:

■ **Front-curtain sync/fill flash.** In this mode, represented by a lightning bolt symbol, the flash fires as soon as the front curtain opens completely. The shutter then remains open for the duration of the exposure, until the rear curtain closes. If the subject is moving and ambient light levels are high enough, the movement will cause a secondary "ghost" exposure that appears to be a stream of light advancing ahead of the flash exposure of the same subject.

■ **Rear-curtain sync.** With this setting, the front curtain opens completely and remains open for the duration of the exposure. Then, the flash is fired and the rear curtain closes. If the subject is moving and ambient light levels are high enough, the movement will cause a secondary "ghost" exposure that appears to stream *behind* the flash exposure. In Program and Aperture-priority modes, the D3000 will combine rear-curtain sync with slow shutter speeds (just like slow sync, discussed below) to balance ambient light with flash illumination. (It's best to use a tripod to avoid blur at these slow shutter speeds.) (See Figure 5.2.)

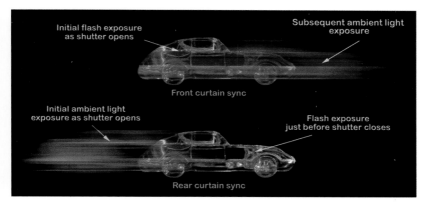

Figure 5.2 First-curtain sync produces an image that trails in front of the flash exposure (top), while second-curtain sync creates a more "natural looking" trail behind the flash image.

- **Red-eye reduction.** In this mode, there is a one-second lag after pressing the shutter release before the picture is actually taken, during which the D3000's red-eye reduction lamp lights, causing the subject's pupils to contract (assuming they are looking at the camera), and thus reducing potential red-eye effects. Don't use with moving subjects or when you can't abide the delay.

- **Slow sync.** This setting allows the D3000 in Program and Aperture-priority modes to use shutter speeds as slow as 30 seconds with the flash to help balance a background illuminated with ambient light with your main subject, which will be lit by the electronic flash. You'll want to use a tripod at slower shutter speeds, of course. It's common that the ambient light will be much warmer than the electronic flash's "daylight" balance, so, if you want the two sources to match, you may want to use a warming filter on the flash. That can be done with a gel if you're using an external flash like the SB-900, or by taping an appropriate warm filter over the D3000's built-in flash. (That's not a convenient approach, and many find the warm/cool mismatch not objectionable and don't bother with filtration.)

- **Red-eye reduction with slow sync.** This mode combines slow sync with the D3000's red-eye reduction behavior when using Program or Aperture-priority modes.

In Shutter-priority and Manual exposure modes, you can select the following three flash synchronization settings:

- **Front-curtain sync/fill flash.** This setting should be your default setting. This mode is also available in Program and Aperture-priority mode, as described above, and, with high ambient light levels, can produce ghost images, discussed below.

- **Red-eye reduction.** This mode, with its one-second lag and red-eye lamp flash, is described above.

- **Rear-curtain sync.** As noted previously, in this sync mode, the front curtain opens completely and remains open for the duration of the exposure. Then, the flash is fired and the rear curtain closes. If the subject is moving and ambient light levels are high enough, the movement will cause that "ghost" exposure that appears to be trailing the flash exposure.

In Auto, Portrait, Child, and Close-Up modes, the following flash sync options are available:

- **Auto.** This setting is the same as front-curtain sync, but the flash pops up automatically in dim lighting conditions.

- **Red-eye reduction auto.** In this mode, there is a one-second lag after pressing the shutter release before the picture is actually taken, during which the D3000's red-eye reduction lamp lights, causing the subject's pupils to contract (assuming they are looking at the camera), and thus reducing potential red-eye effects. Don't use with moving subjects or when you can't abide the delay.

- **Flash off.** This is not really a sync setting, although it is available from the same selection screen. It disables the flash for those situations in which you absolutely do not want it to pop up and fire.

In Night Portrait mode, only slow synchronization flash and flash off modes are available:

- **Auto slow sync.** This setting allows the D3000 to select shutter speeds as slow as 30 seconds with the flash to help balance a background illuminated with ambient light with your main subject, which will be lit by the electronic flash. Best for shooting pictures at night when the subjects in the foreground are important, and you want to avoid a pitch-black background. I recommend using a tripod in this mode.

- **Auto red-eye reduction with slow sync.** Another mode that calls for a tripod, this sync setting mode combines slow sync with the D3000's red-eye reduction pre-flash. This is the one to use when your subjects are people who will be facing the camera.
- **Flash off.** Disables the flash in museums, concerts, religious ceremonies, and other situations in which you absolutely do not want it to pop up and fire.

Guide Numbers

Guide numbers, usually abbreviated GN, are a way of specifying the power of an electronic flash in a way that can be used to determine the right f/stop to use at a particular shooting distance and ISO setting. A GN is usually given as a pair of numbers for both feet and meters that represent the range at ISO 100. For example, the Nikon D3000's built-in flash has a GN in i-TTL mode of 12/39 (meters/feet) at ISO 100 (Lo 1). In Manual mode, the true guide number is a fraction higher: 13/43 meters/feet. To calculate the right exposure at that ISO setting, you'd divide the guide number by the distance to arrive at the appropriate f/stop.

Using the D3000's built-in flash as an example, at ISO 100 with its GN of 43 in Manual mode, if you wanted to shoot a subject at a distance of 10 feet, you'd use f/4.3 (43 divided by 10), or, in practice, f/4.0. At 5 feet, an f/stop of f/8 would be used. Some quick mental calculations with the GN will give you any particular electronic flash's range. You can easily see that the built-in flash would begin to peter out at about 13 feet if you stuck to the lowest ISO of 100, because you'd need an aperture of f/2.8. Of course, in the real world you'd probably bump the sensitivity up to a setting of ISO 800 so you could use a more practical f/8 at 13 feet, and the flash would be effective all the way out to 20 feet or more at wider f/stops.

Working with Nikon Flash Units

If you want to work with dedicated Nikon flash units, at this time you have six choices: the D3000's built-in flash, the Nikon SB-900, SB-700, SB-600 (now discontinued), SB-400 on-camera flash units, and the SB-R200 wireless remote flash.

In automatic mode, the built-in flash must be activated by manually flipping it up when not using one of the Scene modes that feature automatic pop-up. This

flash is powerful enough to provide primary direct flash illumination when required, but can't be angled up for diffuse bounce flash off the ceiling. It's useful for balanced fill flash, but can not operate in Commander mode, which allows the built-in flash to trigger one or more off-camera flash units. (You'll need to use the SB-700, SB-900, or SU-800 to trigger additional off-camera flash units.) You can use Manual flash mode from the **Built-in flash** entry in the Shooting menu, and dial down the intensity of the built-in flash to 1/32 power.

Because the built-in flash draws its power from the D3000's battery, extensive use will reduce the power available to take pictures. For that reason alone, use of an external flash unit can be a good idea when you plan to take a lot of flash pictures.

The Nikon SB-900, SB-700, discontinued SB-600, and entry-level SB-400 are more powerful than the built-in flash, and each has the advantage of elevating the flash unit above the lens to reduce red-eye effects. The SB-900 is currently the flagship of the Nikon flash line up, and has a guide number of 34/111.5 (meters/feet) when the "zooming" flash head (which can be set to adjust the coverage angle of the lens) is set to the 35mm position. It has all the features of the D3000's flash unit, plus Commander mode, repeating flash, modeling light, and selectable power output, along with some extra capabilities.

For example, you can angle the flash and rotate it to provide bounce flash. It includes additional, non-through-the-lens exposure modes, thanks to its built-in light sensor, and can "zoom" and diffuse its coverage angle to illuminate the field of view of lenses from 8mm (with the wide-angle/diffusion dome attached) to 120mm on a D3000. The SB-900 also has its own powerful focus assist lamp to aid autofocus in dim lighting, and has reduced red-eye effects simply because the unit, when attached to the D3000, is mounted in a higher position that tends to eliminate reflections from the eye back to the camera lens.

The SB-700 and SB-600 have lower guide numbers, but share many of the SB-900's features, including zoomable flash coverage equal to the field of view of a 16-56mm lens on the D3000 (24-85mm settings with a full-frame camera), and 14mm with a built-in diffuser panel. Each has a built-in modeling flash feature, but lacks repeating flash, accessory filters, and an included flash diffuser dome, which can be purchased separately. Other differences include:

The entry-level SB-400 is a good choice for most Nikon D3000 applications if you don't need flash very often. It's built specifically for entry-level Nikon cameras like the D3000, and has a limited, easy-to-use feature set. It has a limited ISO 100 guide number of 21/68 at the 18mm zoom-head position. It tilts up for bounce flash to 90 degrees, with click detents at the 0, 60, 75, and 90 degree

marks. Unless you feel the need for an emergency flash or fill flash unit that's only slightly more powerful than the D3000's built-in flash, for the most flexibility, you might want to consider the SB-700.

The Nikon SB-R200 is a specialized wireless-only flash that's especially useful for close-up photography, and is often purchased in pairs for use with the Nikon R1 and R1C1 Wireless Close-Up Speedlight systems. Its output power is low at 10/33 (meters/feet) for ISO 100 as you might expect for a unit used to photograph subjects that are often inches from the camera. It has a fixed coverage angle of 78 degrees horizontal and 60 degrees vertical, but the flash head tilts down to 60 degrees and up to 45 degrees (with detents every 15 degrees in both directions). In this case, "up" and "down" have a different meaning, because the SB-R200 can be mounted on the SX-1 Attachment Ring mounted around the lens, so the pair of flash units are on the sides and titled towards or away from the optical axis. It supports i-TTL, D-TTL, TTL (for film cameras), and Manual modes.

Flash Techniques

This next section will discuss using specific features of the Nikon D3000's built-in flash, as well as those of the Nikon dedicated external flash units.

Using the Zoom Head

External flash zoom heads can adjust themselves automatically to match lens focal lengths in use reported by the D3000 to the flash unit, or you can adjust the zoom head position manually. With flash units prior to the SB-900, automatic zoom adjustment wasted some of your flash's power, because the flash unit assumed that the focal length reported comes from a full-frame camera. Because of the 1.5X crop factor, the flash coverage when the flash is set to a particular focal length is wider than is required by the D3000's cropped image. The SB-900 and SB-700, on the other hand, automatically determine whether your camera is an FX-format, full-frame model, or is a DX ("cropped sensor") model like the Nikon D3000, and adjusts coverage angle to suit.

You can manually adjust the zoom position yourself, if you want the flash coverage to correspond to something other than the focal length in use. Just press the Zoom button on the SB-900, and turn the selector dial clockwise to increase the zoom value, or counterclockwise to decrease the zoom value. You can also adjust the zoom position by repeatedly pressing the Zoom button.

Flash Modes

The TTL automatic flash modes available for the SB-900 and SB-700 are as follows:

- **AA:** Auto Aperture flash. The Speedlight uses a built-in light sensor to measure the amount of flash illumination reflected back from the subject, and adjusts the output to produce an appropriate exposure based on the ISO, aperture, focal length, and flash compensation values set on the D3000. This setting on the flash can be used with the D3000 in Program or Aperture-priority modes.

- **A:** Non-TTL auto flash. The Speedlight's sensor measures the flash illumination reflected back from the subject, and adjusts the output to provide an appropriate exposure. This setting on the flash can be used when the D3000 is set to Aperture-priority or Manual modes. You can use this setting to manually "bracket" exposures, as adjusting the aperture value of the lens will produce more or less exposure.

- **GN:** Distance priority manual. You enter a distance value, and the SB-900 adjusts light output based on distance, ISO, and aperture to produce the right exposure in either Aperture-priority or Manual exposure modes. Press the Mode button on the flash until the GN indicator appears, then press the SEL button to highlight the distance display, using the plus and minus buttons to enter the distance value you want (from 1 to 65.6 feet, or 0.3 to 20 meters). The SB-900 and SB-700 will indicate a recommended aperture, which you then set on the lens mounted on the D3000.

- **M:** Manual flash. The flash fires at a fixed output level. Press the Mode button until M appears on the SB-900's LCD panel. Press the SEL button and the plus or minus buttons to increase or decrease the output value of the flash. Use the table in the flash manual to determine a suggested aperture setting for a given distance. Then, set that aperture on the D3000 in either Aperture-priority or Manual exposure modes.

- **RPT:** Repeating flash. The flash fires repeatedly to produce a multiple flash strobing effect. To use this mode, set the D3000's exposure mode to Manual. Then set up the number of repeating flashes per frame, frequency, and flash output level, as described in Chapter 4. Set flash output level with Function button 1 and the selector dial, and choose the number of flashes with the Function button 2 and the selector dial. Finally, press Function button 3 and rotate the selector dial to choose the frequency.

BURN OUT

When using repeating flash with the SB-900, or *any* large number of consecutive flashes in any mode (more than about 15 shots at full power), allow the flash to cool off (Nikon recommends a 10-minute time out) to avoid overheating the flash. The SB-900 will signal you with a warning chime that rings twice when it's time for a cooling-off period. The flash will actually disable itself, if necessary, to prevent damage. The SB-700 has improved burn-out protection.

Working with Wireless Commander Mode

Wireless flash is somewhat of a challenge with the D3000, particularly since the camera's built-in flash can't be set to Commander mode and used to control other compatible flash units. To work wireless, you'll have to connect a unit like the Nikon SB-900 or SB-700 to serve as your flash "Commander" to communicate with and trigger other flash units. Nikon offers a unit called the SU-800, which is a commander unit that has no built-in visible flash, and which controls other units using infrared signals. This section will provide some basic information that you can use. You'll want to read the instructions that came with your external flash if you need more guidance.

The SU-800 has several advantages. It's useful for cameras like the D3000, which lack a built-in Commander flash. The real advantage the SU-800 has is its "reach." Because it uses IR illumination rather than visible light to communicate with remote flashes, the infrared burst can be much stronger, doubling its effective control range to 66 feet.

Once you have set your external flash as the Master/Commander, you can specify a shooting mode, either Manual with a power output setting you determine from 1/1 to 1/128, or for TTL automatic exposure. When using TTL, you can dial in from −1.0 to +3.0 flash exposure compensation for the master flash. You can also specify a channel (1, 2, 3, or 4) that all flashes will use to communicate among themselves. (If other Nikon photographers are present, choosing a different channel prevents your flash from triggering their remotes, and vice versa.)

Each remote flash unit can also be set to one of three groups (A, B, or C), so you can set the exposure compensation and exposure mode of each group separately. For example, one or more flashes in one group can be reduced in output compared to the flashes in the other group, to produce a particular lighting ratio effect. You'll find instructions for setting exposure mode, channel, and compensation next (for the built-in flash).

Setting Commander and Remote Modes for the SB-900

Setting modes for the SB-900 has been greatly simplified, compared to the previous SB-800. Just rotate the On/Off/Wireless mode switch to the Remote or Master positions. In Remote mode, the SB-900 will be triggered by the Commander flash unit in its group. In Master mode, the SB-900 will serve as the trigger for the other flash units in a group. (The SB-700 has similar features, but it wasn't available until several months after this book was published, so I haven't tested it.)

You'll want to tell the SB-900 which Channel to use, and which Group it belongs to so that it responds to/controls the other units in its group. You'll need to do this separately for each of the SB-900 units you are working with, if you're using more than one. Here are the (confusing) steps to follow (I recommend doing several dry runs to see how setting up multiple flashes works before trying it "live."):

1. On the master flash, press **Function Button 1** to highlight **M (Master)**.

2. Press the Mode button, then spin the selector dial to choose the flash mode you want to use for that flash unit, from among TTL, A (Auto Aperture), M (Manual), or - -. Then, press OK.

Tip

At the - - setting, the master flash is disabled; it will trigger the other units, but its flash won't contribute to the exposure—except if you're shooting very close to the subject using a high ISO setting. Tilt or rotate the flash head away from your subject to minimize this spill-over effect.

3. Press **Function Button 2**, and rotate the selector dial to choose the flash compensation level. The amount of EV correction appears at the right side, opposite the master flash's mode indicator.

4. Press **Function Button 1** to move on to the **Group Selection** option. Press OK to choose **Group A**, or rotate the selector dial to choose **Group B** or **C**, then press OK to confirm the group you've chosen.

5. If you're using additional SB-900 flash units with this master flash, set their flash modes and exposure compensation individually by repeating Steps 2, 3, and 4 with the master flash.

6. If you'll be using even more SB-900 flash units, set up those groups as you did for Group A, but specify the group name you'll be using for the additional units (either B or C).

7. Once the modes for all the flash units have been set on the master flash, press **Function Button 2** and rotate the selector dial to set a channel number that the master flash will use to control its groups.

8. Now take each of the remote flash units and set the correct group and channel number you want to use. Just press **Function Button 1** on each remote flash, and rotate the selector dial to specify the group name. Press OK. Then press **Function Button 2** and rotate the selector dial to choose the channel number, and then press the OK button. You're all set!

Connecting External Flash

You have three basic choices for linking an external flash unit to your Nikon D3000. They are as follows:

- **Mount on the accessory shoe.** Sliding a compatible flash unit into the Nikon D3000's accessory shoe provides a direct connection. With a Nikon dedicated flash, all functions of the flash are supported.

- **Connect to the accessory shoe with a cable.** The Nikon SC-28 and SC-29 TTL coiled remote cords have an accessory shoe on one end of a nine-foot cable to accept a flash, and a foot that slides into the camera accessory shoe on the other end, providing a link that is the same as when the flash is mounted directly on the camera. The SC-29 version also includes a focus assist lamp, like that on the camera and SB-900.

- **Multi-flash cables.** The Nikon SC-27/SC-26 TTL Multi-Flash Sync Cords can be used to connect TTL flash units to each other or through the AS-10 TTL Multi-Flash Adapter or SC-28 TTL Remote Cord for multi-flash operation. However, this three-pin connector does not support i-TTL or D-TTL operation. You may wish to use it with older Nikon flash units.

- **Wireless link.** An external Nikon electronic flash can be triggered by another Master flash such as the Nikon SB-900 in Commander mode or by the SU-800 infrared unit. If you don't mind setting exposure manually, many non-Nikon flash units have built-in "slave" sensors to allow them to be triggered by any other flash unit. Such flash may have both "digital" and "non-digital" modes (sometimes assigned other names). In digital mode, the slave flash will ignore the pre-flash emitted by units like the Nikon Speedlights, and only trigger when the second, main flash burst occurs.

Using Flash Exposure Compensation

If you are using Program, Shutter-priority, Aperture-priority, or Manual exposure modes, you can manually add or subtract exposure to the flash exposure calculated by the D3000. Use the information display (press the INFO button to display it). Choose Flash Compensation, and press OK; then press the up/down directional buttons to select values between –3EV (darker) to +1 EV (lighter) in 1/3 EV increments. As with ordinary exposure compensation, the adjustment you make remains in effect until you zero it out by restoring the +/–0 value in the information display.

Chapter 6

Shooting Tips

Here you'll find tips on settings to use for different kinds of shooting, including recommended settings for some Playback, Shooting, and Setup menu options. You can set up your camera to shoot the main type of scenes you work with, then use the charts that follow to make changes for other kinds of images. Most will set up their D3000 for my All Purpose settings, and adjust from there.

Default, All Purpose, Sports—Outdoors, Sports—Indoors

	Default	All Purpose	Sports Outdoors	Sports Indoors
Exposure Mode	Your choice	P	S	S
Metering Mode	Your choice	Matrix	Matrix	Matrix
Playback Menu				
Playback Folder	Current	All	Current	Current
Display Mode	Highlights, RGB Histogram, Data	Highlights, RGB Histogram, Data	Highlights, RGB Histogram, Data	Highlights, RGB Histogram, Data
Image Review	On	On	Off	Off
Shooting Menu				
Set Picture Control	Standard	Standard		
Vivid	Vivid			
Image Quality	JPEG Fine	RAW+JPEG Basic	JPEG Fine	JPEG Fine
Image Size	Large	Large	Large	Large
White Balance	Auto	Auto	Auto	Tungsten or Fluorescent—Fine-tune if necessary
ISO Sensitivity	Auto	Auto	ISO 400	ISO 1600
Maximum sensitivity	--	1600		
Minimum shutter speed	--	1/30		
Active D-Lighting	Off	Off	Off	Off
Color Space	sRGB	SRGB	sRGB	sRGB
Noise Reduction	On	Off	Off	Off

	Default	All Purpose	Sports Outdoors	Sports Indoors
Release mode	Single frame	Single frame	Continuous	Continuous
AF-area mode	Auto-area	Auto-area	Auto-area	Auto-area
Focus mode	AF-S	AF-S	AF-C	AF-C
AF-assist	On	On	Off	Off
Built-in flash	TTL	TTL	TTL	TTL
Setup Menu				
Auto info display	On	On	Off	Off
Auto Off Timers	Norm	Norm	Long	Long
Remote on duration	5 min.	5 min	1 min.	1 min
Viewfinder options—Rangefinder	Off	Off	Off	Off

Stage Performance, Long Exposure, HDR, Portrait

	Stage Performances	Long Exposure	HDR	Portrait
Exposure Mode	S	M	A	A
Autofocus Mode	AF-C	M	AF-S	AF-S
Metering Mode	Spot	Center-weighted	Matrix	Center-weighted
Playback Menu				
Playback Folder	Current	Current	Current	Current
Display Mode	Highlights, RGB Histogram, Data	Highlights, RGB Histogram, Data	Highlights, RGB Histogram, Data	Highlights, RGB Histogram, Data
Image Review	Off	On	Off	On

Shooting Menu

	Stage Performances	Long Exposure	HDR	Portrait
Set Picture Control	User—Reduce contrast, Add sharpening	Neutral	Standard	Portrait
Image Quality	RAW+JPEG Basic	RAW+JPEG Basic	RAW+JPEG Basic	RAW+JPEG Basic
Image Size	Large	Large	Large	Large
White Balance	Tungsten—Fine-tune if necessary	Auto	Select preset	Auto
ISO Sensitivity	ISO 800-1600	ISO 200-400	ISO 200	ISO 200
Maximum sensitivity				
Minimum shutter speed				
Active D-Lighting	On	On	Off	On
Color Space	Adobe RGB	Adobe RGB	Adobe RGB	Adobe RGB
Noise Reduction	On	On	Off	Off
Release mode	Single frame	Single frame	Continuous	Single frame
Focus mode	AF-C	M	AF-S	AF-S or M
AF-area mode	Dynamic area	Single point	Auto-area	Single point
AF-assist	Off	Off	Off	Off
Built-in flash	TTL	TTL	TTL	TTL

	Stage Performances	Long Exposure	HDR	Portrait
Setup Menu				
Auto info display	On	On	Off	Off
Auto Off Timers	Norm	Norm	Long	Long
Remote on duration	1 min.	5 min.	1 min.	1 min.
Viewfinder options—Rangefinder	Off	On	Off	On

Studio Flash, Landscape, Macro, Travel, E-Mail

	Studio Flash	Landscape	Macro	Travel	E-Mail
Exposure Mode	A	A	A	A	A
Autofocus Mode	AF-S	AF-S	M	AF-S	AF-S
Metering Mode	Matrix	Matrix	Spot	Matrix	Matrix
Playback Menu					
Playback Folder	Current	Current	Current	All	All
Display Mode	Highlights, RGB Histogram, Data	Highlights, RGB Histogram, Data	Highlights, RGB Histogram, Data	Highlights, RGB Histogram, Data	Highlights, RGB Histogram, Data
Image Review	Off	On	On	On	On
Shooting Menu					
Set Picture Control	Portrait	Landscape	Neutral	Vivid	Standard
Image Quality	RAW+JPEG Basic	RAW+JPEG Basic	RAW+JPEG Basic	JPEG Fine	JPEG Basic

	Studio Flash	Landscape	Macro	Travel	E-Mail
Image Size	Large	Large	Large	Large	Small
White Balance	Flash	Auto	Select preset	Auto	Auto
ISO Sensitivity	ISO 200	ISO 200	ISO 400-800	ISO 400-800	ISO 400-800
Maximum sensitivity					
Minimum shutter speed					
Active D-Lighting	Off	Auto	Low	Auto	Off
Color Space	Adobe RGB	Adobe RGB	sRGB	sRGB	sRGB
Noise Reduction	On	On	Off	Off	Off
Release mode	Single frame	Single frame	Continuous	Single frame	Single Frame
Focus mode	AF-S	AF-S	M	AF-S	AF-A
AF-area mode	Single point	Single point	Single point	Auto-area	Auto-area
AF-assist	Off	Off	On	Off	Off
Built-in flash	TTL	TTL	TTL	TTL	TTL
Setup Menu					
Auto info display	On	On	Off	Off	On
Auto Off Timers	Norm	Norm	Long	Long	Norm
Remote on duration	5 min.	5 min.	1 min.	1 min.	5 min.
Viewfinder options—Rangefinder	Off	Off	On	Off	Off

Index